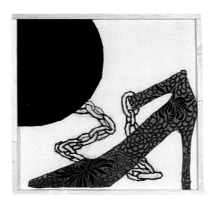

WOMEN OF THE WORLD

A GLOBAL COLLECTION OF ART

CURATED BY CLAUDIA DeMONTE

FOREWORD BY ARLENE RAVEN

Pomegranate

SAN FRANCISCO

PUBLISHED BY

Pomegranate Communications, Inc.
Box 808022, Petaluma, CA 94975
www.pomegranate.com

Pomegranate Europe Ltd.
Unit 1, Heathcote Business Centre
Hurlbutt Road
Warwick, Warwickshire CV34 6TD, U.K.

Women of the World, organized by Claudia DeMonte, opened in June 2000 at White Columns (New York). The exhibition has traveled to the Flint Institute of Art (Michigan), Mobile Museum (Alabama), Brenau University (Georgia), the University of Maryland, the Tucson Museum, the Museum of the Southwest (Texas), the University of New England (Maine), and Volvo Gallery (Stockholm, Sweden), among other venues. At the time of this printing, it is scheduled as the inaugural show at the International Museum of Women (San Francisco) and is expected to visit the Tallinn Art Hall (Estonia) and the 2004 Olympics (Athens, Greece).

CREDITS
Front cover: (Top row, l–r) Sylvie Brigitte Amoussou-Guenon, Benin; Karlisima (El Salvador); Olga Okuneva (Russia). *(Middle row, l–r)* Suad Al-Attar (Iraq); Claudia Terstappen (Germany); Margarida Kendall (Portugal). *(Bottom row, l–r)* Neo Matome (Botswana); Astari Rasjid (Indonesia); Lina Jonikiene (Lithuania).
Back cover (clockwise from top left): Marija Dujmovic (Bosnia and Herzegovina); Thuraya Al-Baqsami (Kuwait); Yasbel Perez (Cuba); Helen Graham (Scotland).
Page 1: Worapanit Jiya-amondej (Thailand). *Page 3:* Nina Kocic (Yugoslavia). *Page 8:* Joscelyn Gardner (Barbados). *Page 11:* Winnie Weoa (Papua New Guinea). *Page 12:* Cecilia Mandrile (Argentina).

Library of Congress Cataloging-in-Publication Data
Women of the world : a global collection of art / curated by Claudia DeMonte.

 p. cm.
 ISBN 0-7649-1334-4 (pbk.)
 1. Women artists—Catalogs. 2. Art, Modern—20th century—Catalogs. I. DeMonte, Claudia, 1947–

 N8354 . W658 2000
 704'.042—dc21 00-022971

Cover and interior design by Jamison Design, Nevada City, California

10 09 08 07 06 05 10 9 8 7 6 5 4 3
PRINTED IN CHINA

CONTENTS

AS THE WORLD TURNS

ARLENE RAVEN

The earliest sun rises on the twenty-first century in Fiji. On the International Date Line, where all days begin and end, Taveneuni Islanders sing, dance, and shake bare bellies at the cameras.

A world away, the "primitive" scene travels via up-to-the-minute technologies to my television, where it is still Fiji's yesterday, in New York.

Times Square, by contrast, is only a few miles from where I sit staring at the screen. At 12:01 A.M., two million squealing sophisticates, guzzling from bottles among rainbows of falling confetti, are squeezed into a cordoned section of midtown Manhattan strenuously patrolled by police.

The Waterford crystal ball reaches its destination atop a radiating advertisement for the Discover card.

Throngs of "native" celebrants—in Jerusalem and Hong Kong, Patagonia and Timbuktu—flash between shots of the international encampment on 42nd Street, hinting that even the most remote motherland can be connected to every other quarter.

At this millennial moment, the global village I enjoy as a digital rectangle from "there," in my own quarters "here," offers a dichotomous picture of "now."

The African American expatriate James Baldwin, who did not live to see the turn of the century, offered that this present time can be "the charged, the dangerous moment, when everything must be reexamined, must be made new." I cannot but reflect on Baldwin's invitation to consider the mandate of today when I turn to the images to be shown together as "Women of the World." Claudia DeMonte must have had such an invitation in mind when she asked artists all over the earth to create a current visual representation of "woman."

DeMonte's process—in its invention and implementation, from conception to selection and exhibition—has been driven by humanitarian and feminist principles. Each piece is identical in size and shape, and each has been made especially for "Women of the World." A rule of "one country, one artist" provided geographical parity for the global gathering to be exemplified in concrete pictorial terms. To borrow a phrase from Virginia Woolf's *Three Guineas*, "Women of the World" is "women's country."

But the panoramic questions—who is woman, what is she?—don't allow for solely generic answers. Female nature as author and subject still inspires volumes that range in focus from the microscopic to the macrocosmic.

Thinking globally, DeMonte always acted locally. To position oneself as a woman in the year 2000, she has argued, requires situating that self in a particular time, space, and place.

As an organizer, therefore, she never made thematic assumptions on the basis of her own experience. Consequently, every work is distinct, uniquely interpreting its unifying theme. And the body of works is never homogeneous, but instead, inclusive, comprehensive, and truly representative.

This curatorial vision demanded unusual effort over an extended period of time. But DeMonte's call for entries finally yielded 174 works from as many locations.

The world rendered by this planetary community of women often comments on the paradoxical nature of the present. At one conceptual pole, woman remains an enduring, endlessly fecund goddess generating the earth and its inhabitants. At the other, she is the oppressed victim of a patriarchal society that wants to subdue her, use her, and even kill her. The discourse of "Women of the World" is rich as well as wide, easily moving within and without this frame of reference.

Negar Pooya provides a contextualizing paradigm. She set her picture in a traditional Iranian mirror frame, from which she wishes a viewer to see her contemporary female spirit. Pooya's dual framework holds the double lens of "Women of the World." Maria José Zamora (Nicaragua) paints one side of her piece white and the other red to assert that life means contradictions. As their own constructed mirrors, the artists' works address the mythic, historical, and ordinary as aspects of multidimensional reflections of self. In so doing, they mirror, as well, the best and the worst of women's lot.

The visionary and the everyday merge to illuminate inspired female labor. Mamialisoa Razanamaro explores the daily life of Malagasy women—the complex, intense, and dignified burdens entrusted to rural women, including preparing food, managing family unity, and protecting the environment. Gyongyi Kaman of Hungary explains that her work examines the relationship between the bodiless (interior) and the (exterior) body: their permanent, changing interactions. Josette Caruana (Malta) describes art making as a magical birth in which the spirit of beauty completes the vitality of nature.

Antigua's Heather Doram paints a woman naked in nature with fluid strokes. Her creative core emanates from the center of her body and flows into the ground. The female ability to spawn progeny and women's record of travail on behalf of the human race unites with her artistic gifts. Such images of mythological woman opening her body to give birth occur throughout history. A Turkish mother goddess, laboring with open legs as she sits on her throne, dates from as early as 6,500 B.C. In a humorous reverse, those who wish may (re)enter the birth canal of Frenchwoman Niki de Saint-Phale's *Hon* (1963) through her gigantic, highly colored and decorated thighs.

Costa Rican Marite Vidales's female figure, as the regenerative axis of the universe, is large in its frame and faces front in the mode of an icon. Jhumka Gupta of India portrays the

Hindu goddess Durga, who symbolizes strength. From Iraq, Suad Al-Attar's painting is a mirage of birth and death. In counterpoint, Reingard Klinger's Madonna reproduces a common statue sold for home prayer services near Salzburg. The "feminine" qualities of this figure, Klinger reflects, are those held in low esteem in secular Austrian society.

Madonnas and Magdalenes alike find their forms and signs in the artifacts of social life. Worapanit Jiya-amondej's cramping pump evokes the circumscribed life of the Thai woman. A gigantic ball and chain attached to the embellished shoe mark women's weighty cultural internment.

DeMonte puts the high heel to service in her own art. *Shoe* (1998), from the "Female Fetish" series, uses the backbreaking design of the slipper and the breath-restricting pewter objects nailed into it to capture the "height of fashion."

Using folk art to inspire her rendering, a stylistic nod to forebears in the Russian Constructivist movement, Olga Okuneva presents a colossal female profile embedded in an architecture blown by the winds of the last century's turbulence. Riham Gahssib portrays an "honor killing": the state-sanctioned murder to which women are still subjected in Jordan. Despina Meiramoglou employs Greek newspaper reports of brutality to take on inequality among the sexes and violence against women in her own environment. Then she digitally modifies and mutates these journalistic accounts of daily reality—and changes the news.

The needle arts, actual methods used in a number of pieces, become a metaphor of honor for women's domestic toil—whether in their homes or the homes of others, in fields, factories, shops, or offices. North American artist Judy Chicago collaborated with expert needleworkers for "The Birth Project" (1980–85), which joined the valorized but largely hidden birth experience with the denigrated "minor" (feminine) practice of needle arts. Pat Derrick, representing England, has woven a striking baby's vest of steel wool. Its pink satin ties underline the defenselessness of the most tender in a world of chronic conflict. Nazia Kahn of Pakistan, as if to assert the power to express selfhood and to heal through the work of the hand, offers a golden raised palm. Raya Turaeva works handmade carpets from pure sheep's wool and Tajik ornaments.

As a gesture against losing the hand/needle, Maureen Hazelle of Ghana and Virginia Tyler of the United States worked together on a piece based on indigenous embroidery designs for women's clothing.

Mary Cassatt depicted *Lydia at a Tapestry Frame* (1881). The artist's sister stands as an example of her gender, class, and time. But Lydia at the spindle or stitching with a needle also holds an implicit symbolic meaning—woman as sacred female creativity, personified as the ancient Spinster.

Cassatt was deeply affected by first-wave feminism at the dawn of the twentieth century.

The "modern age" was to celebrate the telephone, the electric light, the automobile, the motion picture camera, the airplane, and even Freud's discovery of the unconscious. Cassatt's largest mural, painted in France and shipped to Chicago to occupy the south tympanum of the Woman's Building, was called *Modern Woman*.

Designed by architect Sophia Hayden and erected as a part of the Chicago World's Fair of 1893, the Woman's Building exhibited exclusively female art and craft—including weaving, lacemaking, embroidery, and china painting as well as oils, watercolors, and sculpture—from around the globe. This remarkable feminist project (a forerunner of "Women of the World") highlights Cassatt's daring scale and imagery.

Modern Woman depicts women and girls gathering apples in an orchard. The stated aim of the artist's all-female mural echoed the feminism of her day in viewing woman apart from her relations with man, in order to establish the essential feminine. In an Eden without Adam, nourishment as well as inherent optimism for the hundred years ahead is literally handed down as the fruit of knowledge from elder to youth.

Adelina Popnedeleva of Bulgaria draws Eve's daughter's hand emerging from a dense, luscious pattern of foliage. Her skin is white and soft; her fingernails a bright red, flashing the seductress. But she has learned of the Biblical tree from her mother. She risks grabbing the apple, hungry for messages and meanings. Tuire Lampila also portrays the responsibility of mother to daughter to educate through passage. In her *Look Inside*, we see a matriarch singing a Finnish sauna-song to her offspring.

The history and continuity of women's work are embedded in this generational woman-to-woman relationship, and intrinsic to "Women of the World." As gestures to acknowledge the contributions of women past and present, the faces and accomplishments of particular people are visualized. Myriam Khun chooses Rigoberta Menchu, the Guatemalan fighter for peace, human rights, and native rights who won the Nobel peace prize in 1992. Business-woman Bah Hadjia Binta Diallo is Sierra Leonean/Guinean Kadijah Zainab Fofanah's subject.

For representation from her homeland, the United States, Claudia DeMonte honors her artistic mentor. She affirms in so doing that there has been and will be a materfamilias—and ultimately a matrilineage—to cherish and celebrate.

The huge societal changes of the last century have given women an opportunity for independence that is exhilarating for those of my generation. My transition into adulthood coincided with the birth and growth of the women's movement. A sense of infinite possibilities, coupled with the freedom to express them—through the Internet, cheap travel, instant communication, the arts, journalism, and politics—have made women a force to be reckoned with.

My pursuits as an artist, veteran university professor, global traveler, and activist led me to pose a universal question to women artists all over our shrinking world: what image represents "woman"? Armed with this concept, I decided to contact one woman artist in every country on Earth and ask them to create a work of art that expressed the essential quality of woman.

This project was conceived without thought to time, money, difficulty, scope, or effort. I am an artist, not a curator or an art historian. I had no idea what I was getting into, either in the amount of work involved or in the rewards I would reap. Each step had its own set of difficulties. I contacted every country in the world, and most responded—some after hundreds of dollars spent on faxes, mail, and telephone calls. I used every means of communication imaginable: personal contacts, museums, embassies, the UN, UNESCO, the

USIA, the U.S. Navy, the Peace Corps, cultural centers, and universities. Some countries came through instantly, but others—because of war, famine, or poverty—never responded. My final list was based more or less on UN membership.

For every wonderful woman artist included, another was regretfully left out. Initially I intended to open the exhibit to anyone interested in participating. Predictably, this led to an onslaught of American artists expressing interest. I was determined, however, to prevent Americans, at least in this one instance, from dominating the world. It would defeat the purpose of the project to have thousands of American women represented, along with a handful of women from other easily accessible countries. So I decided to use an equalizing system: one country, one artist.

In solving one problem, I instantly created another. Who should represent the U.S.? Certainly not me as organizer. None of the many suggestions given to me by curators, collectors, and friends seemed right. After much thought, I selected my most influential teacher, my mentor, my Art Mother. This woman taught me what I value as an artist, a person, and a teacher. Because she is (and wishes to remain) a recluse, she has asked to remain anonymous. I have honored her wish. There are people in life without whom we would not be fulfilled. For me, she is that person.

With my husband, the sculptor Ed McGowin, I have traveled to more than seventy-five countries, looking at art, how it is made, and who makes it. It was during a trip to the remote Himalayan regions of Bhutan and Tibet that the idea for this project was born. We were finishing research for a book being written by the artist Nell Sonnemann on contemporary appliqué. She had asked us to go to Bhutan and Tibet to collect samples. The Tibetan landscape is dotted with elaborately appliquéd tents, always a blue design on white and often incorporating other colors in giant emblematic designs. Our search led us through the side streets of old Lhasa to a Tibetan tent factory. There, in medieval conditions, we found women engaged in the multilayered process of creating appliqués. Bolts of cloth were strewn on cold dirt or cement floors in dimly lit rooms abuzz with sewing machines and hands stitching at a fast, steady pace. The factory was run by men, but all the work was done by women. It was an impressive and busy place.

We were so inspired by the creative energy, the massive pieces emerging from formless cloth, that we wanted to work there on our own ideas. With the Tibetan tentmakers, I began to create new designs for appliqué, making patterns of everyday objects usually associated with women, such as high-heeled shoes, toasters, and handbags. But it suddenly dawned upon me that these images are so culture-specific that they were simply not

translatable to these Tibetan women. I pondered this for months after my return.

My own work deals, often humorously, with the roles of women in contemporary society. Having worked in cultures as disparate as Saudi Arabia and Thailand, I wondered what images would represent woman to females in these cultures. That is, I wanted to translate my work into global terms. Although concepts like "cross-cultural" have become clichés, my entire life, from my childhood to my career as a teacher and an artist, has been based on just such concepts.

Raised in Astoria, Queens, in New York City, I grew up in a microcosm of the world with the Manhattan skyline as backdrop. Queens is the most ethnically diverse county in the U.S., with the most heavily used library system. Thirty languages were spoken at my high school. In my neighborhood we all described ourselves, as many first- and second-generation Americans did in the fifties, as Italian, Polish, Greek, and so on. We relished each other's food, teased each other about our backgrounds, and tried never to lose the traditions that were the only baggage our ancestors could afford to bring with them. I was blessed with open-minded parents who judged people only by their deeds and the contents of their minds. This exposure to Chinese, Indians, Latinos, and African Americans as people to know, to respect, and to socialize with was a gift few gave their children. My parents gave it sincerely, and gift-wrapped it with subscriptions to *National Geographic*. They told us wondrous stories of the red wedding dress worn by the daughter of a Chinese friend, and the tall, handsome Sikh bridegroom who married the girl upstairs. My parents did not have the opportunity to travel the world except through books, but they gave me both the opportunity to see it and the sense to value it and its peoples.

In the sixties, when I learned in my undergraduate studies of the great Mayan and Aztec ruins so close to our country, I was furious that I had not been told of them before. How could American textbooks teach us only of the Egyptian pyramids when these monuments were on our country's borders? In college, I had the benefit of being taught art history by a woman who never showed a slide of something she hadn't seen in person. This is impressive, considering that the list of courses she taught included Western, Indian, Chinese, and Japanese art history. I couldn't believe someone had seen, had stood before, all these things. "See the ceiling at San Agnese in the Piazza Navona," she would say, "but also eat chocolate gelati at Tre Scalini." Her compelling descriptions of exotic locales kindled my dream to travel. Like her, I became convinced that everyone should see the Lake Palace Hotel in Udaipur before they died.

Thus, since my early twenties I have seized every opportunity to travel. It seems as necessary to my being as food. There is nowhere I wouldn't go—the more remote, the more

fulfilling. Eleven years after college graduation I carefully stepped into a rickety wooden boat on a lake in Udaipur, was given marigold necklaces, and was transported forever into the glories of the experience. Travel begets travel. You meet people who live in other places and are invited to do more traveling. Through chance encounters and the kindness of strangers, I have made lifelong friends.

In all my travels I have been most interested in places least touched by Western influence. All travelers want to see places before they are "ruined," I suppose. But I have learned that Western influence is everywhere. In traveling to Irian Jaya, on the western side of the island of New Guinea, I flew on a small prop plane filled with vegetables and a dead dog being brought home for burial. After walking three days into the Dani highlands—peopled with men wearing only penis gourds and women suckling piglets—I found Coca-Cola at a mission. At first I was disappointed, but I have learned that these cultural juxtapositions fuel new ways of seeing. The reality is that Western influence, although far-reaching, is not all-encompassing. We too have been influenced.

It was my intention in this project to preserve the diverse styles and traditions of each

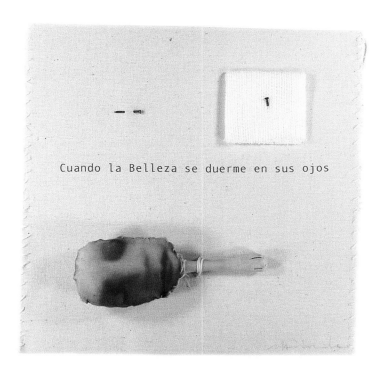

Cuando la Belleza se duerme en sus ojos

country, with the inevitable influences from other countries. I did not judge the works by the insular standards of the Western contemporary art world. Nor did I seek to find the most famous woman artist in each country. Although many are well known and have shown internationally, others are not known at all. They are just women artists pursuing their work, seriously, without fame or major recognition. This project was designed to be expansive, not restrictive. I wanted to underscore the differences in how art is made and perceived.

The results were beyond my dreams, works I could never have predicted. Groups of ideas and techniques seemed to be emerging, but they crossed all geographic boundaries. The artists' responses were as diverse in media as in imagery. The survival of local customs is evident in the adherence to traditional crafts, such as embroidery and appliqué techniques, from Uzbekistan, Kazakhstan, Azerbaijan, Canada, Seychelles, and Sri Lanka. Conversely, new technological advances in digital art showed up everywhere, from Malaysia to Austria to Argentina. I once made a series of cutout women's images called The Luxury of Exercise:

only in the West are we affluent and lucky enough to bear the "burden" of exercising to stay in shape. Many of the arriving pieces made me remember this project, for they depicted women gracefully carrying bundles on their heads, women working in the fields, women in refugee camps, women without rights of any kind.

The only limitation I imposed on the artists was the request that works submitted measure eight inches (20 cm) square. The works would thus fit into standard manila envelopes and could be easily photocopied onto standard-size typing paper. Having the works all the same size would increase the visual impact of their exhibition. My size restrictions were often not followed closely. Nonetheless, the slight variations in size and shape brought a special, unexpected life into the project. It reminded me of not being able to color within the lines as a child!

This project, like this essay, tumbled out of my heart. In it my personal experiences and professional interests coalesced with those of women around the globe. Although this concept was my brainchild, its creativity springs from the artists involved, and the bulk of the credit should go to them. In honoring these women, who worked for free and gave of themselves, it is important to value each voice, to know that each has a story: the single parent teaching the blind in Zambia, the head of women's rights in Uzbekistan, the veiled Afghanistani woman mourning her murdered brother. All of these women are making art, all are willing to participate, and all are donating their work to be auctioned off for charity to help other women. I have a special connection to each of them, to each country (not to mention a great contemporary stamp collection).

This project is neither a geography lesson nor a demonstration of my ability to make connections. It is an expression of the human spirit at the beginning of the twenty-first century, from people whose voices have rarely been heard. Now they finally get to write their own lyrics.

CLAUDIA DEMONTE
New York

This project would never have happened without the support of the University of Maryland's General Research Board, the art development committee of an anonymous foundation, whose check suddenly appeared in the mail, and the Anchorage Foundation of Texas. I also wish to thank Agnes Gund and Daniel Shapiro; this project owes much to their early generosity and sustained faith. Then there are the friends, associates, government agencies, international organizations, and individuals all over the world who put their time and energy into locating artists. My thanks to you all.

For help at every stage of the project, and for his continuous advice, integrity, and great sense of humor I thank Tom Sokolowski. For support from the very beginning and for giving the project its first official venue, thanks to Paul Ha.

The University of Maryland gave me time, money, support staff, and space to work, but most of all it has given me one of the great gifts of my life: the opportunity to teach its students.

For housing me, feeding me, and listening to me for my entire adult life, I owe good memories to Katie Schlumberger Jones—who was right: what she really gave me was the friendship of her children . . . and now her grandchildren. Thanks to Nina Auchincloss Straight. Hugh Steers: we miss you.

Gabriella and Ben Forgey saved me from train disasters, bad weather, and the ups and downs of life. To them, and to their bright and beautiful daughters Elisa and Tina, I say: you have enriched this project, and every aspect of my life.

For their help at on various aspects of the project, I thank Eleanor Adams, Liz Anderson, Leo Altschul, Rene Barilleaux, Mary Barone, Tulik Beck, Jamie Bennett, Anne Bohnn, Montien Boonma, Maya Chebib, Tom Claburn, Carole and Jack Cohn, Marthena Cowart, Andrea Damesyn, Kristie Everett, Bill Fagaly, Ann Fuchs, Ileen Gallagher, Dee Garrett, Barbara Gillman, Ken Goldglit, Peggy Goodwill, Betsy Gotbaum, Grace Grauppi-Pillard, Pat Grysavage, June Hargrove, Alana Heiss, John Henry, Michael Hertzberg, Jolee Hirsch, Preuit Hirsch, Caroline Hollingsworth, the International Council of Women in the Arts, Barbara Johnson, Shirley Kenny, Tina Lochran, Eva Lundsager, Patti and Gavin MacCleod, Betsy Magee, Gracie Mansion, Cathy McAullife, Hadassah and Tom Morgan, Keith Morrison, Rosie Nilsson, the Open Society, Andrea Pampanini, Laura Phillips, Ed Purcell, Thierry Renard, Randy Rosenberg, Jack Rosenthal, Lauren Ross, Marion and Daniel Rubin, Deborah Sale, Joe Schenk, Helene Seeman, Joe Simo, Alexa Stellings, Susan Fisher Sterling, Linda and Isaac Stern, Margie and Mike Stern, Edward Sullivan, Zuzu Tabatai, Karen Thomas, Betty Tompkins, Thord Thordeman, Eugenie Tsai, Mary Ann Tuscalas, Perry Walker, Rysard Wasko, Jason Wright, Cathy Wyler, and Bob Yassin.

Mary Ann Tighe: thank you for thirty years of sharing so many things—our Italian background, C.U, Md., D.C., birthdays, Art, and the glories of N.Y.—but most of all for knowing the importance of family. And thanks to Judy Bachrach, great writer, great mother, great friend, and to David Driskell for his wisdom and humanity. Special thanks to Tony Solomon and the memory of Connie, for our world travels and a thousand shared experiences.

Thank you, Zena and Mike Wiener, for believing, for caring, and for Thursdays. Thanks to Peaches Gilbert, who has always been there for me, and to her husband Eddie, whose ship came in, took us sailing, and gave us Sasha, Bee and Zoe. Penny Edelman taught me how to breathe and the importance of red. Thanks to Jania Victoria and Dean Ziff for loving Miami, architecture, and us; to Jane Whitney and Lindsey Gruson for sharing friends, good food, and life; to Lily and Philippe Staib for giving my husband and me the opportunity to live and work in Thailand; to Abdullah bin Faisal bin Turki al Saud for New Year's Eve in the Arabian desert and for being the brother I never had.

Special thanks to Judith Moses, for her energy and optimism, and to the research assistants, whose organizational abilities are amazing: Joley King and Milagros Ponce de Leon. For tireless in-depth work day and night: thank you, Natalia Blanch. And to Cecilia Mandrile, assistant curator: it just would not have been possible on any level without you.

I thank my sister, Cynthia DeMonte, our parents' daughter, blessed with their minds and their hearts—always been there for me and for all who need her. I only wish Dad had lived to see the success of DeMonte Associates! And, of course, thanks to her husband, Abe Figueroa, for becoming part of our family.

And thanks to my husband, Ed McGowin, for helping me develop the concept. But most of all for sharing art, life, and the wonders of the world; you're the one with whom I will always want to dance to Latin music.

To my mother, Ammeda DeMonte, for her courage
and constant inspiration, and to the memory of my
beloved father, Joseph DeMonte.

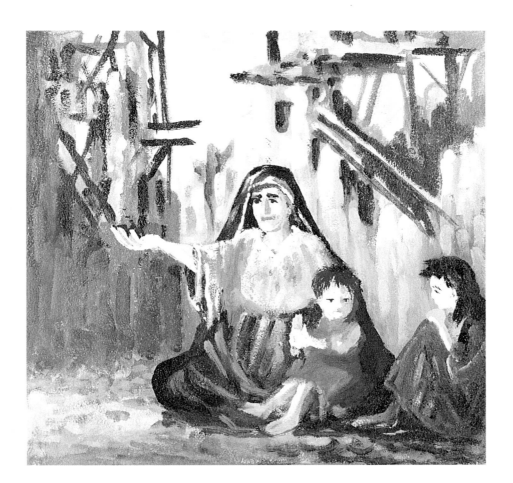

GHATOL

I raise the cry of the forgotten and oppressed women of Afghanistan, but I am unable to depict the grave and horrible plight of our women in my painting.

I portray an Afghan widow and her two children begging in the ruined city of Kabul. Kabul is called the City of Beggars. Hundreds of women, children, and men have no other option but to hope for alms in the streets. Throughout Afghanistan the fundamentalists—with their barbaric rule—subject thousands of people to social scourges.

A few weeks into this painting, I lost my dear and only brother when the Taliban tortured and killed him. In the hell named Afghanistan, life for all people is full of tragedies and miseries.

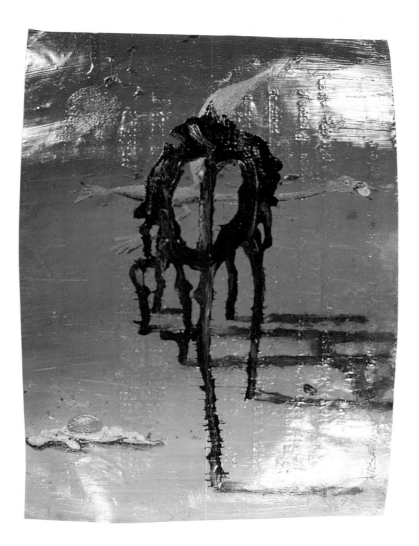

MARJANA ESKI (B. 1963)

The phenomenon of creation intrigues me. It is imperceptible but present everywhere. Women symbolize harmony and sacrifice, which I represent with an egg that flies around and distributes her seed in the air. Without women, life and the universe would be temporary, and matter would not regenerate.

Marjana Eski's award-winning work has been shown in Albania, including the National Gallery of Fine Art and the Soros Foundation. She is a clothing designer, a former teacher of graphic art at the Academy of Fine Arts, and a former deputy president of the Association of Women Painters in Albania.

FATIHA IGUELMAMENE

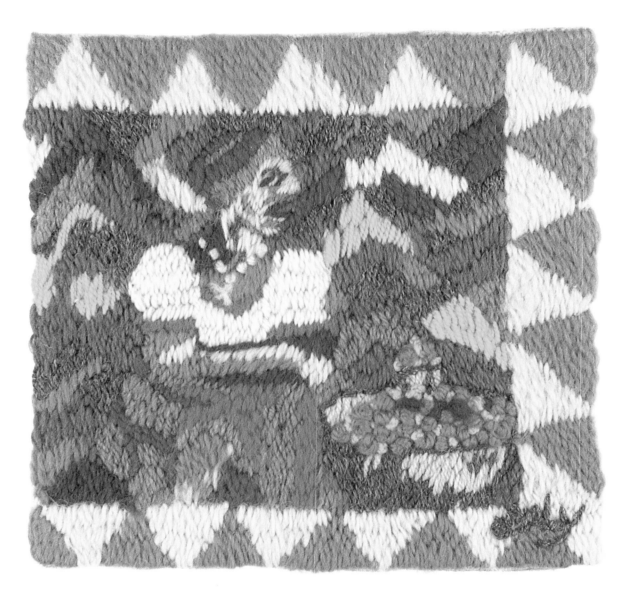

JOSEFINA MANZAILA EMMANUEL (B. 1967)

Josefina Manzaila Emmanuel teaches textile art and printmaking at the Escola Nacional de Artes Plasticas. She has participated in national and international group exhibitions and cofounded GJAP, Young Brigade of Fine Artists.

HEATHER DORAM (B. 1953)

My art, like the bark paintings that inspire me, is layered with multiple meanings. It is like the concentric circles of the "sacred water holes," representing the continuous cycle of life.

I work with felt, an ancient yet modern material. My art tool is the sewing machine. Stitches create lines and add texture and body to the felt. Stitches and beads are part of my visual vocabulary; they serve as ornament and structure.

My work presents emotional landscapes that document my life and that of Caribbean women. I intend to provoke my viewers, leading to moments of connection.

Heather Doram has been in solo and group exhibitions in Antigua and abroad. In 1995 her work represented the Savannah College of Art & Design in the Venice Biennial in Italy. Doram designs and constructs costumes for Antigua's Carnival, and she designed Antigua's national dress.

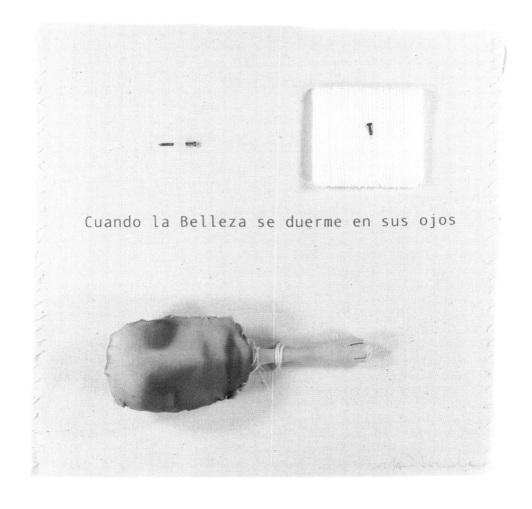

Cuando la Belleza se duerme en sus ojos

CECILIA MANDRILE (B. 1969)

My work is about human fragility and its strategies for reconstruction. After living outside my country, I have noticed how women preserve the memories of injustice and tragedy; they are the survivors of the painful circle of history. *When Beauty falls asleep in their eyes* is dedicated to those who try to mend the wounds of the world.

Cecilia Mandrile exhibits her work in national and international exhibitions, including the United States. She has taught drawing, printmaking, and design at universities and private schools in Argentina and the United States.

NENE GYULAMIRIAN

Nene Gyulamirian immigrated to the Washington, D.C., area in 1991. She has participated in solo and group shows in the United States and abroad, including Norway, Japan, Turkey, and Germany.

JENNY POLLAK

REINGARD KLINGLER

Although Vienna, as the site of the United Nations Conference Center, seeks to portray a cosmopolitan and open social and cultural image, there are, nevertheless, strong traditional beliefs connected with women and their social roles. The Madonna in my work is sold near Salzburg for home prayer services. Her feminine posture is a visual icon in Austria's somewhat secular culture. It communicates that caring, nurturing, and modesty are "feminine" virtues. The figure's place in religion makes it impervious to social critique. This icon defines qualities as "feminine"—qualities vital for Western capitalist societies but with the lowest remunerative and social prestige.

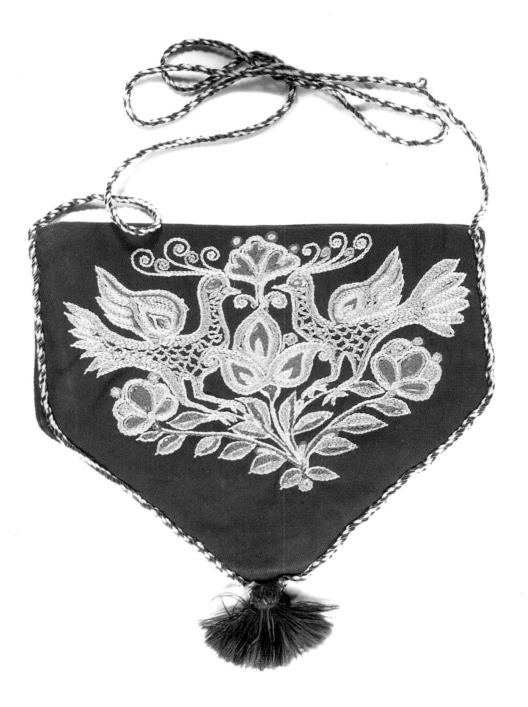

ARIFA MAMADOVA

JESSICA MAYCOCK

The women in my life influence my view of all women. They deserve respect regardless of their ethnicity. Like flowers, they are vibrant, attractive, beautiful, graceful, strong, delicate, warm, fertile, and nurturing.

Jessica Maycock teaches ceramics and owns a tileworks studio. Her award-winning work has appeared in group shows in the Bahamas and the United States.

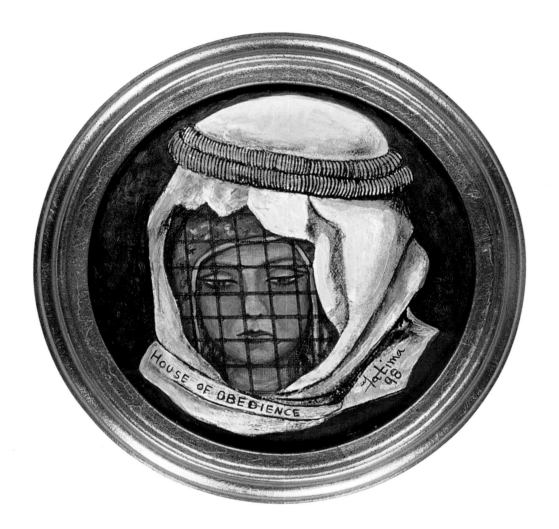

FATIMA FAKHRO (B. 1943)

House of Obedience represents women in Arab society. Women are trapped in the cage of men's expectations. They are expected to obey harsh rules set upon them by a male-dominated society.

Fatima Fakhro was raised under her country's strict Muslim moral codes. In 1980 she came to the United States to study at the Maryland Institute College of Art. For the first time she was independent and could express herself freely.

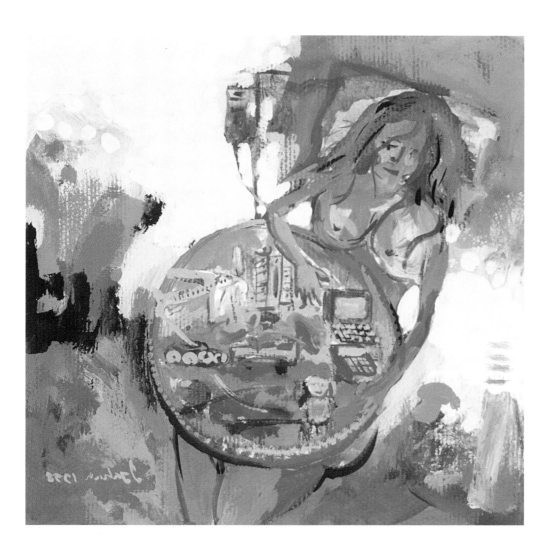

ISHRAT JAHAN (B. 1971)

The theme of my painting is that civilization flourishes from the womb of a woman, but the world is burdened by civilization and has become sick.

Ishrat Jahan's work has appeared in group exhibitions for the last ten years, including the annual art exhibitions at the Institute of Fine Art, Dhaka University.

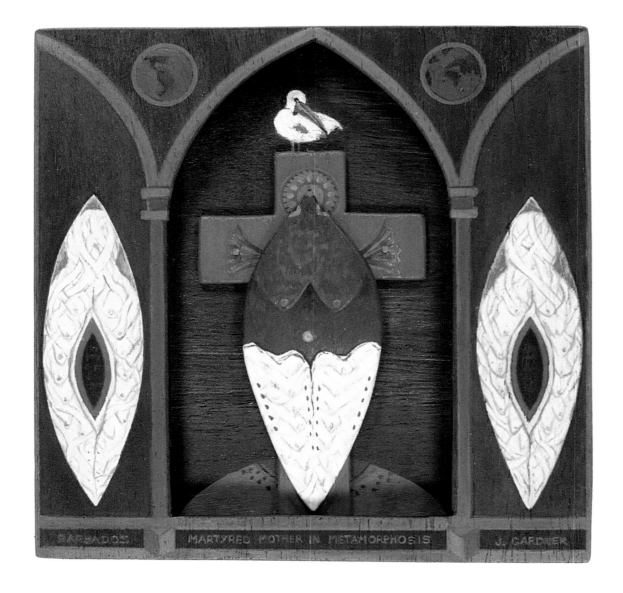

JOSCELYN GARDNER

In my work, the Creole artist, as "mother," becomes the island of Barbados. Raped by a history of male invasions (her Amerindian, European, and African ancestry), she gives birth to a harmonious world of racial, sexual, and religious understanding. Yet in an eternal cycle of metamorphosis, she sacrifices herself for this tenuous balance.

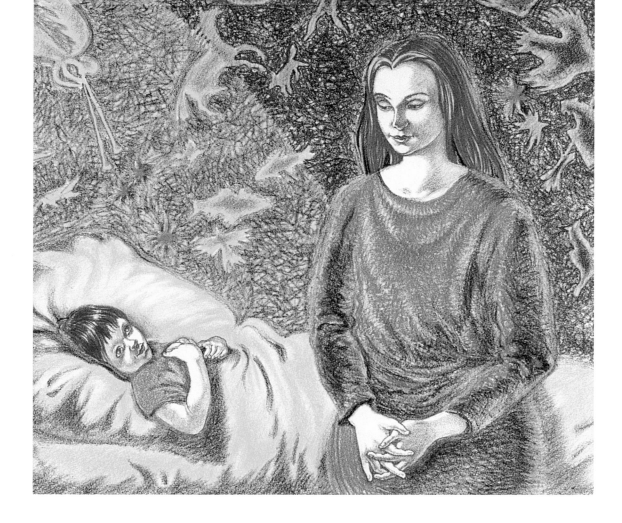

OLGA KRUPENKOVA (B. 1969)

Olga Krupenkova is a graphic artist and an illustrator of children's books. She has exhibited in local and international exhibitions, and her art is collected throughout Europe.

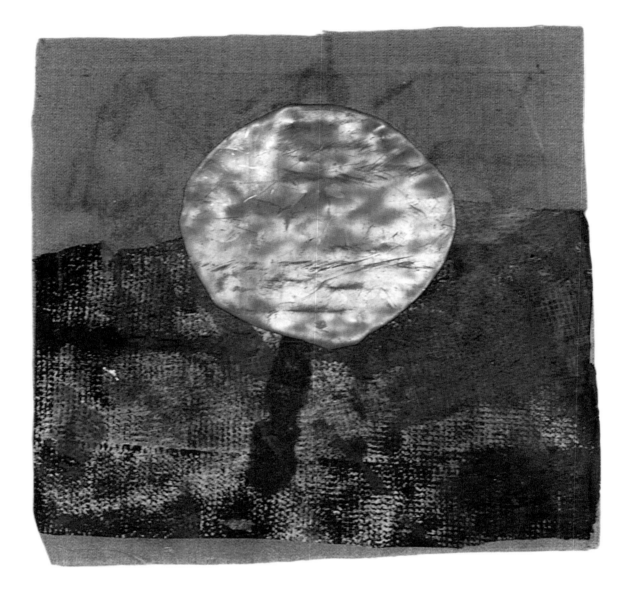

NICOLE CALLEBAUT

The symbol that best suggests "woman" is a circle. She is as generous and warm as the sun, she is as mysterious as the moon, and she has a round morphology. My work is a visual reflection of change, creation, and destruction.

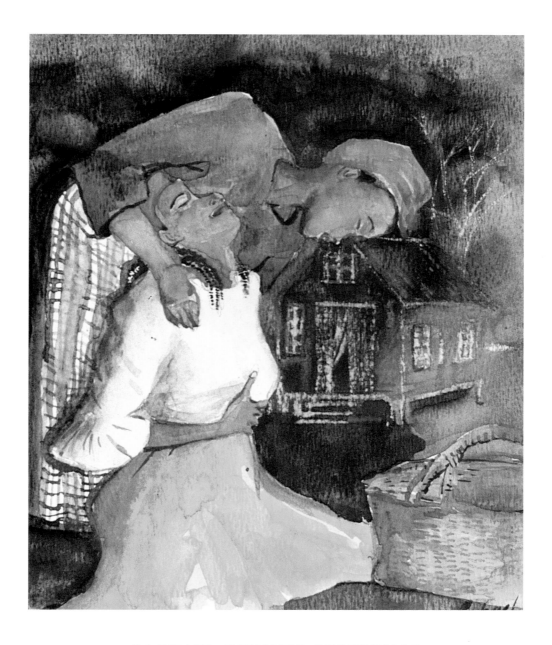

RACHAEL HEUSNER-SUPERVILLE

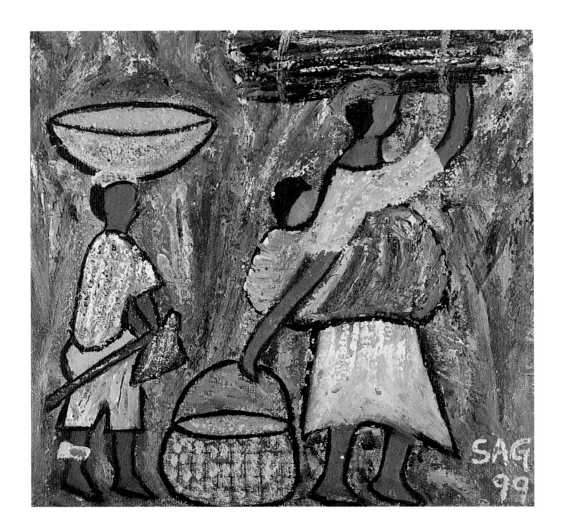

SYLVIE BRIGITTE AMOUSSOU-GUENON (B. 1966)

My painting shows the rural life of African women. They are weaker than men, but they are also sources of beauty and life despite their status or tribe. Unfortunately, women are often ill-treated.

Painter and jewelry designer Sylvie Brigitte Amoussou-Guenon has been an administrator for various cultural organizations. Her work has appeared in painting and design exhibitions in Benin, Nigeria, and Burkina Faso since 1996.

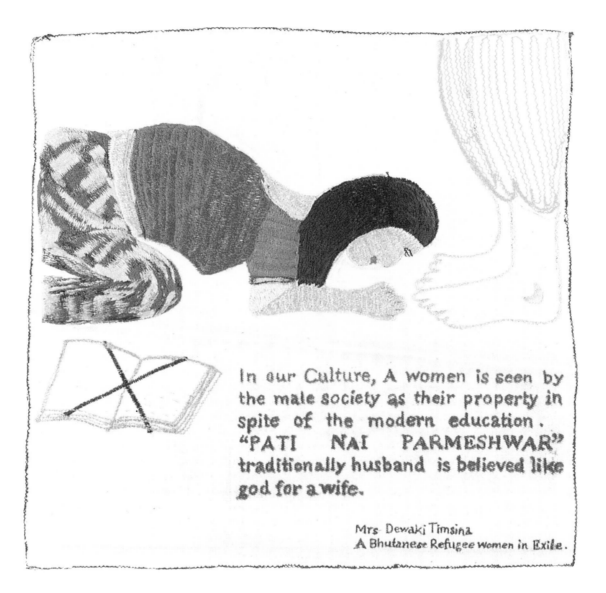

In our Culture, A women is seen by the male society as their property in spite of the modern education. "PATI NAI PARMESHWAR" traditionally husband is believed like god for a wife.

Mrs. Dewaki Timsina
A Bhutanese Refugee women in Exile.

DEWAKI TIMSINA

Dewaki Timsina lives in a Bhutanese refugee camp in Nepal.

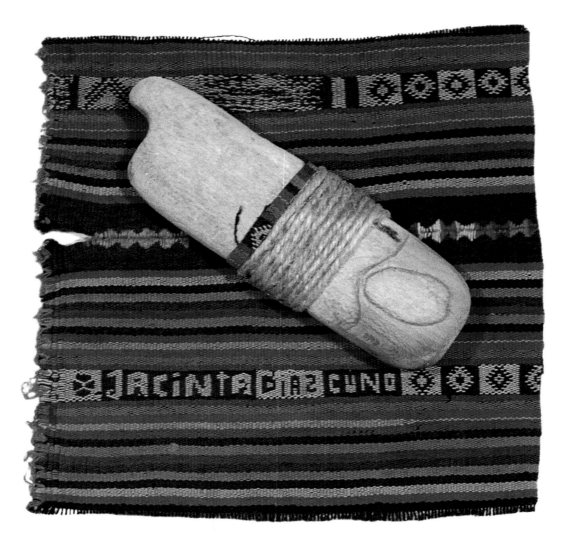

TERESA CAMACHO HULL

The idea of "woman" is represented by wool, wood, and jute; there is warmth, resilience, and conductivity through unity. She is a very strong fiber, resistant to stretching.

Teresa Camacho Hull's work, including multimedia and interdisciplinary efforts, has been exhibited in South America, Europe, and the United States. She has an arts and ceramics studio in Maryland, where she lives with her husband and five children. They consider themselves citizens of the world, embracing and gaining strength from cultural diversity.

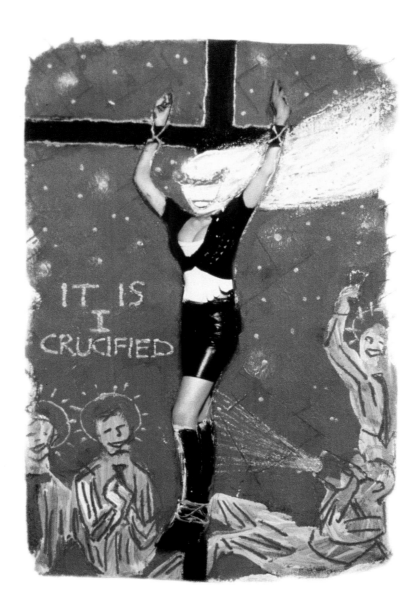

MARIJA DUJMOVIC (B. 1969)

Marija Dujmovic grew up in Sarajevo and lived there until the war broke out in Bosnia in 1992. She attended the Corcoran School of Art in Washington, D.C., for two years and carried the experience back to Sarajevo for her final two years of study. She lives in Zagreb, Croatia, where she is the proud mother of Leon, her young son. For her, home is where the family is, and she is happy to have a wonderful one.

NEO MATOME (B. 1967)

The Batswana woman helps uphold the social fabric of her country, but she does not have the same power as a man. Like gems, women are unique and worthy, with different strengths and abilities that deserve the opportunity to sparkle. Women must be able to assert themselves culturally, professionally, and politically. We must work together to achieve these goals. The Setswana saying "Kgetsi ya tsie e kgonwa ke go tshwaraganelwa" conveys the same message as the proverb "Unity is strength." (Note: The country is Botswana, the people are called Batswana, and the language is Setswana.)

Neo Matome exhibits nationally and internationally and promotes art in Botswana. In 1998 she received the Marshall Frankel Foundation Award for a residency at the Vermont Studio Center.

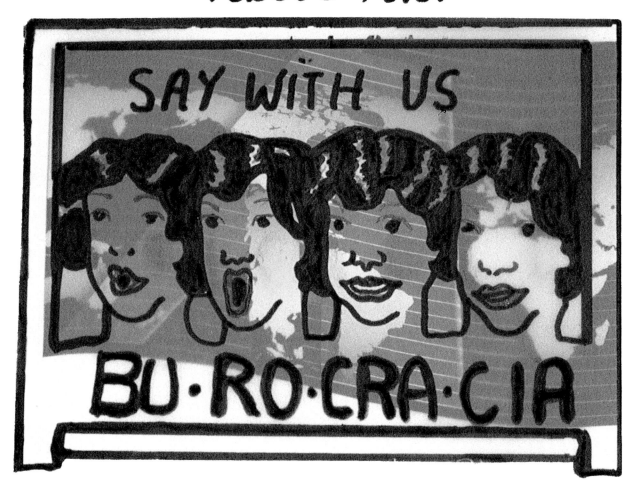

ANNA BELLA GEIGER (B. 1933)

My work focuses on the connections between cartography, memory, and the female condition.

Anna Bella Geiger's work is in the Museum of Modern Art, New York City; Centre Georges Pompidou, Paris; the Victoria and Albert Museum, London; Musee d'Art et Histoire, Geneva; the Institute of Contemporary Art, Chicago, among others. Geiger and critic Fernando Cocchiarale wrote Abstraçao Geométrica e Informal; Vanguardia Brasileira nos anos 50 *(Funarte, 1987).*

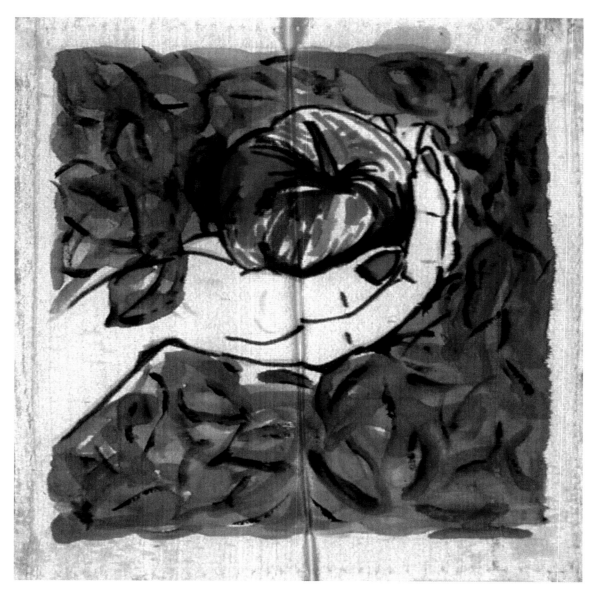

ADELINA POPNEDELEVA (B. 1956)

This drawing represents Eve's daughter's hand. The woman is a temptress and an instigator because she passes on the dangerous apple of knowledge.

Adelina Popnedeleva has had eight solo shows in Bulgaria and France and has participated in group shows since 1988. Popnedeleva lives in Sofia and works in textiles, installations, and video.

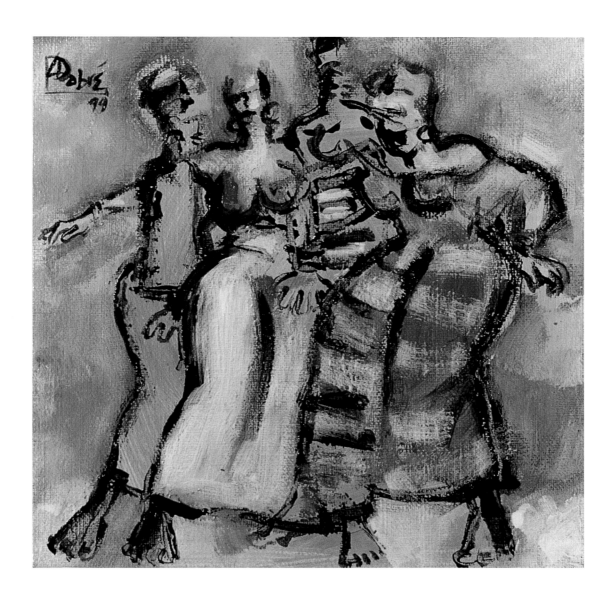

CATHERINE DABRE (B. 1963)

My painting represents the traditional woman's dance after a marriage ceremony. The dance is a dialogue with God and the ancestors. Each woman wears beautiful clothes and displays her talents. In West Africa, the marriage celebration is a large, social occasion for family members and the rest of the community.

Catherine Dabre started painting in 1984. She concentrated on jazz scenes until she began depicting people and landscapes from the Sahelian region. She lives in Burkina Faso with her husband and two children.

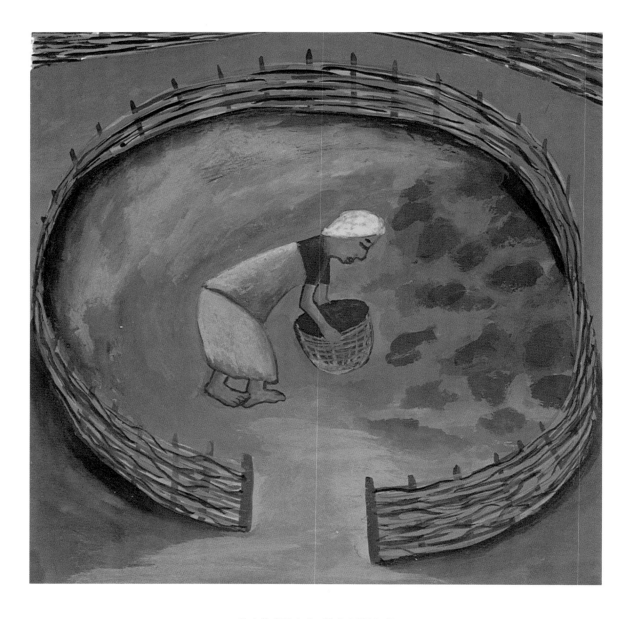

CARITAS KAMELO

THEOUNG MIM

Being a Cambodian woman means having to maintain two identities. One is my parents' expectations and the other is who I really am. My painting depicts these two sides, which are sometimes hard to blend.

Theoung Mim arrived in America with her family in the mid-1980s. She volunteers at nursing homes and performs traditional Cambodian dances at local functions. She studies at the Teachers of English to Speakers of Other Languages Program at California State University of Sacramento. Her primary desire is to return to Cambodia and help rebuild it.

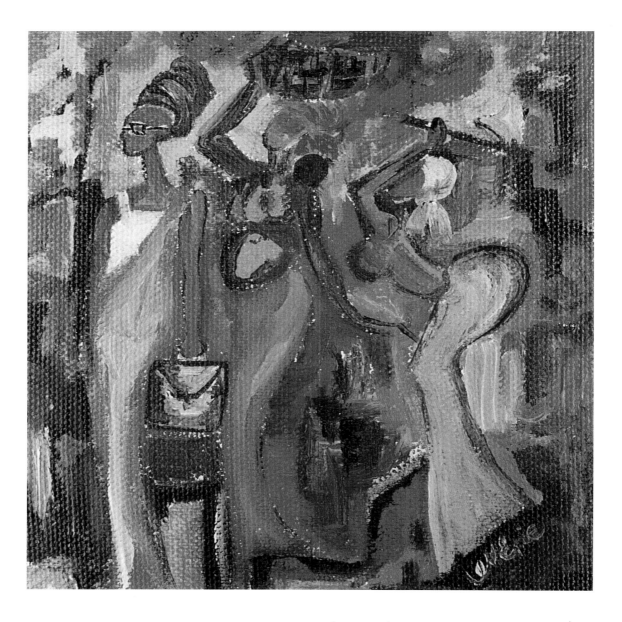

IRENE EPIE (B. 1962)

Irene Epie went to school in England, Egypt, Liberia, Canada, and Cameroon. Her award-winning work has appeared in three exhibitions.

LINDA EDWARDS

This woven square of fabric covering a square of wool felt forms a narrative based on the work of Sadi Plant, who recovers forgotten histories of women and technology. Historically, women have woven their own veils and clothing. According to patriarchal sources, the veils are disguises to hide the terrifying origin of life.

Weaving predates printing as a system of information storage. In the Middle Ages square paper charts stored the directions to reproduce designs.

Linda Edwards has participated in group exhibitions, such as "Women Beyond Borders" in Toronto in 1998. She created "From Hairy Legs to Go Ask Alice" at the Art Gallery of Ontario in 1997, and she had a solo show in 1995.

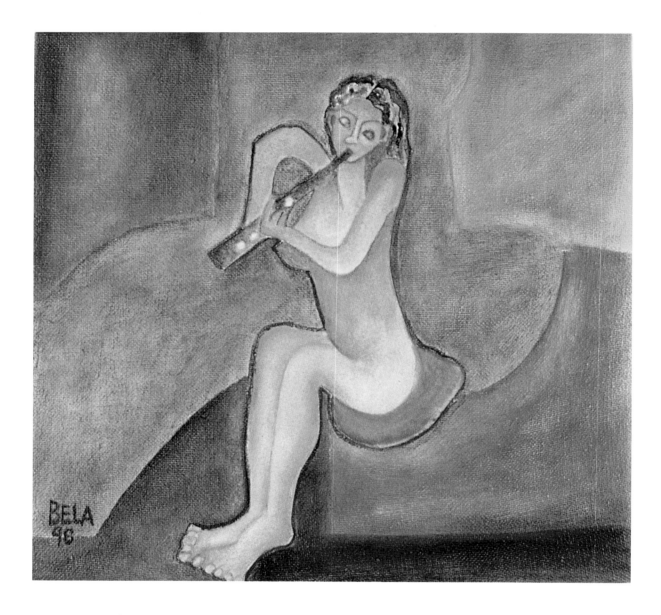

ISABEL LIMA SEQUEIRA DOS SANTOS DUARTE (B. 1940)

With two colleagues, Isabel Lima Sequeira dos Santos Duarte founded the cooperative National Center for Workmanship, a school for young people that operated for about twenty years. In 1989 she started Atelier Bela, in which she creates paintings, tapestries, weavings, and batik. She teaches batik, weaving, and tapestry to children. Her work has been exhibited in Portugal, Belgium, Brazil, Austria, the United States, and France.

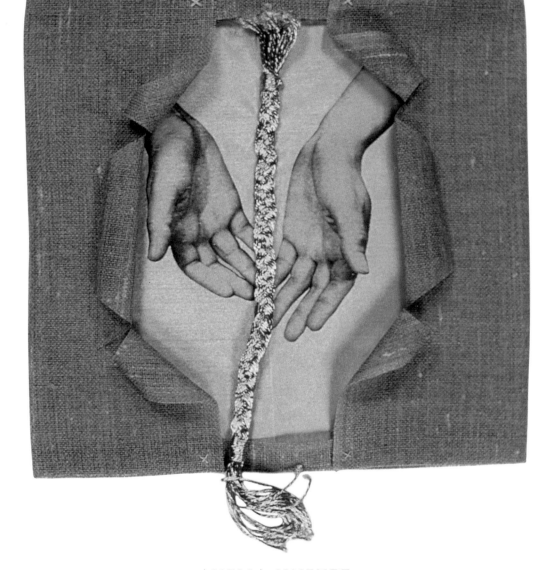

AMELIA JIMENEZ

In *Consagracion* ("Consecration"), the hands and the cut braid evoke ritual and rite, change, transition, an aperture, and a new form. I chose copper, silk, and fabric because they have a relationship with the earth and transformation.

Amelia Jimenez has taken part in exhibitions in Canada, Mexico, Chile, Colombia, Puerto Rico, Germany, and Ecuador. Jimenez won the New Pioneer Arts Award in Toronto.

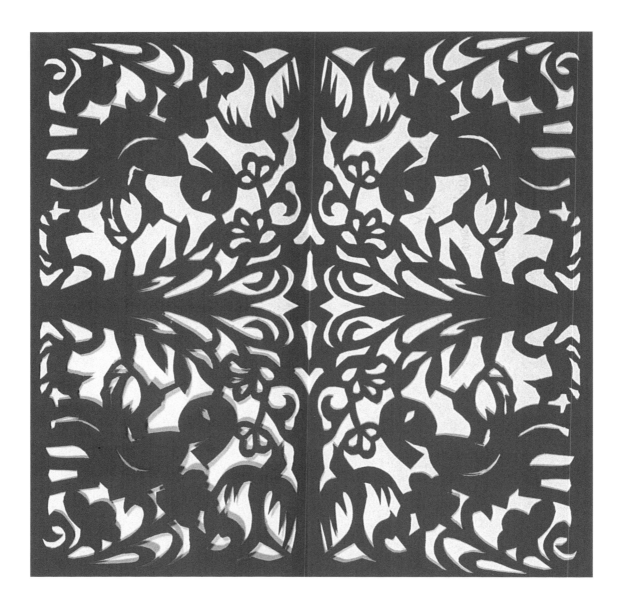

YU SHI XU

Paper-cutting is a traditional Chinese art. My work shows a Chinese woman embroidering in a flower garden.

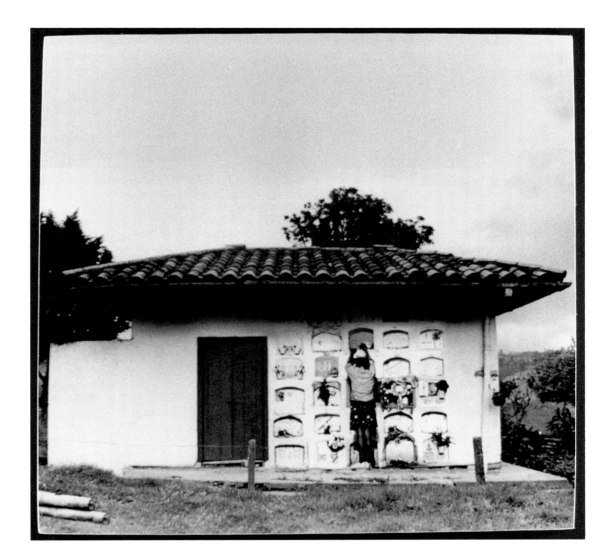

ADRIANA DUQUE (B. 1968)

I have tried to create a relationship among women, the house, and camposanto, referring to continuing assaults of violence that plague farm families in my country. The houses are invaded and the occupants are killed or displaced. Surviving farm women live with a phantom who watches their nests fall from trees.

Adriana Duque was born in Manizales, Colombia, a small town where she has lived almost all her life. She has participated in exhibitions in Colombia. Even before her studies at the Academy of Arts, Duque's daily life and her dreams were closely related to art.

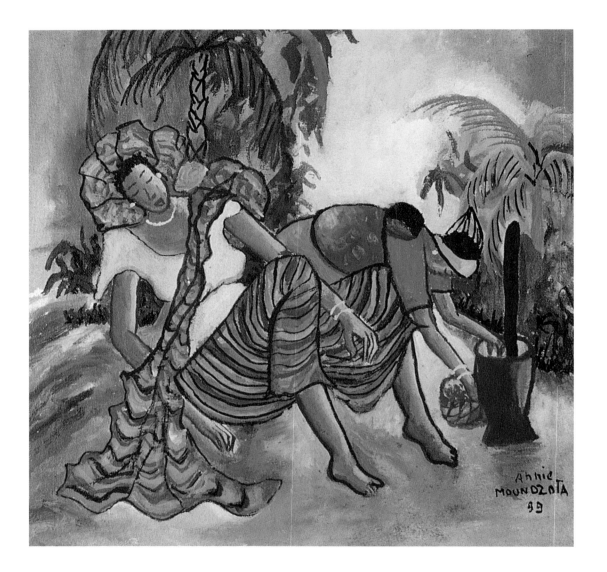

ANNIE MOUNDZOTA (B. 1967)

Annie Moundzota attended the Poto-Poto School of Painting. She has taken part in the African Biennial of Plastic Arts and international exhibitions.

MARITE VIDALES

This canvas is an analogy of women and nature, with woman as the central form in the
environment. I incorporated platano leaves as part of the Costa Rican landscape. I also show
how the cycles of the moon affect water, women, and the earth.

SONJA VUK (B. 1966)

Women grow up on fairy tales, love novels, and romantic movies. We expect a perfect prince to wake us with a kiss. When dreams become reality and we think "the perfect one is here," we find there is no recipe in fairy tales for everyday life. Reality hurts.

Sonja Vuk's work has appeared in solo and group exhibitions in Croatia and Hungary, among others.

YASBEL MARIA PÉREZ DOMÍNGUEZ

MARLEN CARLETIDOU (B. 1961)

*Marlen Carletidou has exhibited in seven solo shows in Cyprus and in group exhibitions in Cyprus and abroad.
She teaches a private art workshop for children, and she is a teacher and facilitator at the Dance Ability Project
in Cyprus.*

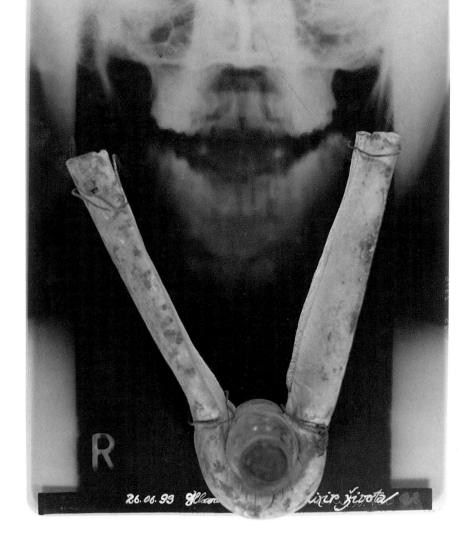

HATA HLAVATA (B. 1959)

After I almost died on 26 June 1999, I made a pledge to live for my children and their education. I also want to help women throughout the world.

Born in Prague, painter and illustrator Hata Hlavata now lives in Germany. Her artwork incorporates electronic media and imagery, light sculpture, and video.

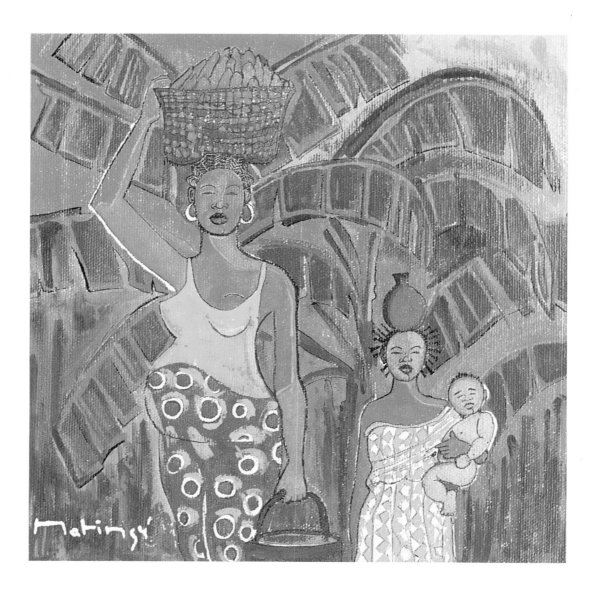

NATHALIE NDOLO (B. 1971)

This pregnant woman is on her way back from the farm. She carries a basket of cassava and tubers and a bucket of water. Her daughter carries her little brother and a pot of water. The girl will not go to school because African custom obliges daughters to help their mothers.

Nathalie Ndolo has a small arts workshop where she draws, paints, and plays music. She decorated a stand at a recent national fair honoring the reconstruction of her country.

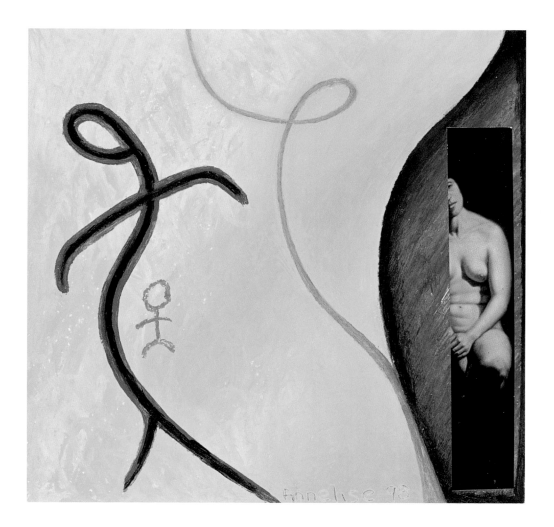

ANNELISE HANSEN

Crossing cultural borders and encountering the global diversity of art, I find that everyone seeks freedom of expression to renew and enrich our lives. Through images we share new ways to understand the world.

We have developed hundreds of cultures and thousands of languages, but we are still afraid of each other. We protect our nations with huge military institutions that can destroy us. Nature knows no borders; nor do today's modern weapons. I support a global culture of peace. We can do this by working toward a healthy planet and peaceful civilizations.

CARLA ARMOUR HUTCHINSON (B. 1966)

In my society, women set the balance and keep the wheels turning. I use colors to symbolize areas in which women triumph. Red represents pain and strength, green speaks of ephemeral existences, ultramarine is the soul (personal spirit), and yellow light signifies divine energy.

The circle represents the eternality of the life force and the connection to all things we achieve through humility (as shown by the sackcloth). The grid stands for multifaceted lives: a board game that women play daily.

Carla Armour Hutchinson is vice president of the Dominica Writers Guild. Her poems are often the catalysts for her paintings. Hutchinson's work is in collections in Europe, the United Kingdom, the United States, Canada, and the Caribbean.

IRIS VIVIANA PEREZ

This oil painting on canvas symbolizes a poor life inside and outside of a woman's prison.

Born in Santo Domingo, Perez studied at the National School of Fine Arts and at the Autonomous University of Santo Domingo, where her work won awards. She has presented four solo exhibitions and taken part in more than thirty collective shows. Perez has been named a Distinguished Visitor by Tegucigalpa, Honduras, and received an FAO medal of recognition for her performance/installation of Hunger's Dance. *Currently, she is secretary general of the Dominican School of Plastic Artists and a professor at the National School of Fine Arts.*

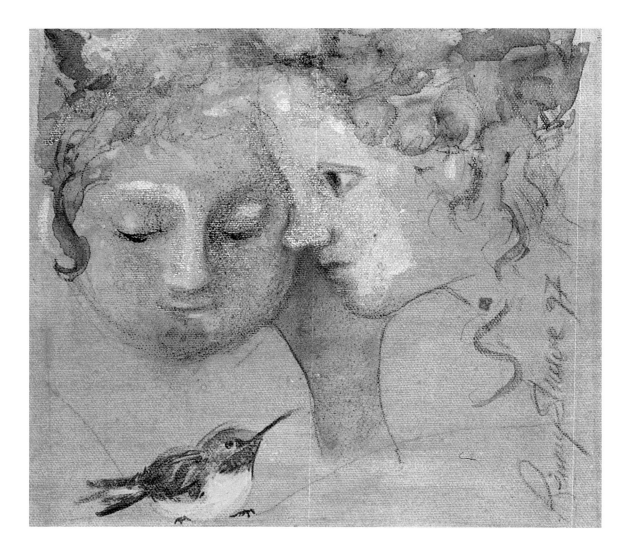

ROMMY E. STRUVE

Women have different facets to their personalities that work together. My painting represents a shy, lonely attitude combined with an aggressive one. The bird expresses freedom; it poses between the two faces and asks for protection.

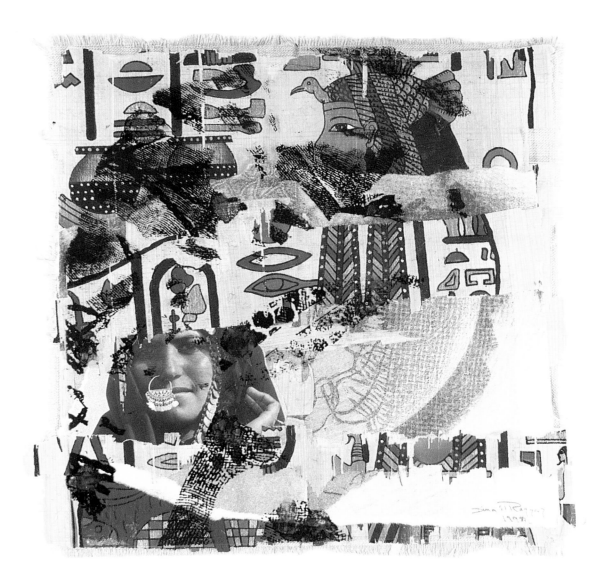

DINA EL RAZZAZ

Egypt's diversified cultures reflect a vast history of customs and faiths. My collages contain fragments of these events to join the past with the present, and the traditional with the contemporary.

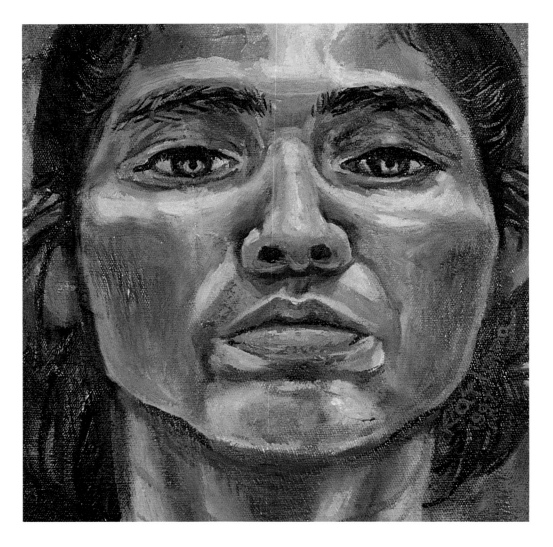

KARLISIMA

This painting represents the way I see myself: as an introspective woman, meditating, with a wisdom gained through experience. I feel strong and proud to represent El Salvador and my Mayan heritage through my work.

Born in San Salvador in 1970, Karlisima came to the U.S. with her siblings in 1984. She attended Washington University in St. Louis, majoring in painting. A winner of several awards and a participant in many group shows since 1991, she teaches art, paints on commission, and is employed as a copyist by the National Gallery of Art, Washington.

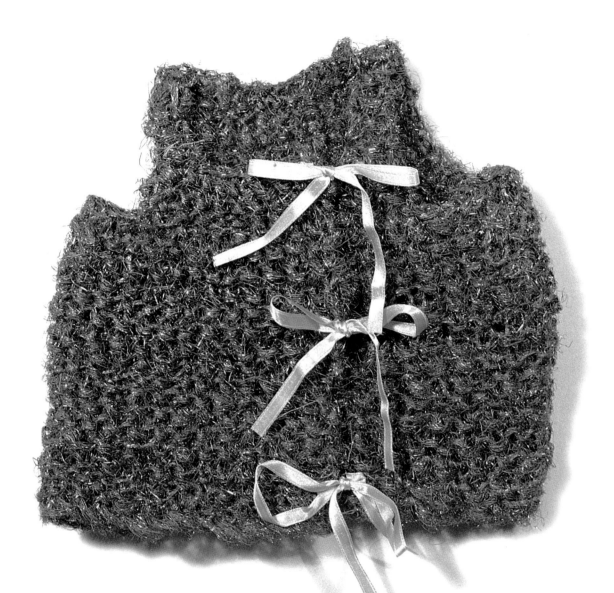

PAT DERRICK (B. 1948)

Women and children are targets in modern warfare. How can a mother protect her child against weapon technology? This piece is a reflection on war victims' desperation. The steel-wool vest symbolizes a mother's anguished attempt to shield her baby from harm

Pat Derrick grew up in Tanzania. Her father always said that children should be seen but not heard; her mother warned her never to cause trouble; her teachers told her to pray for a good husband. These experiences shape her work as a feminist artist. She is supported by Elvin, her loving husband (the prayers worked!).

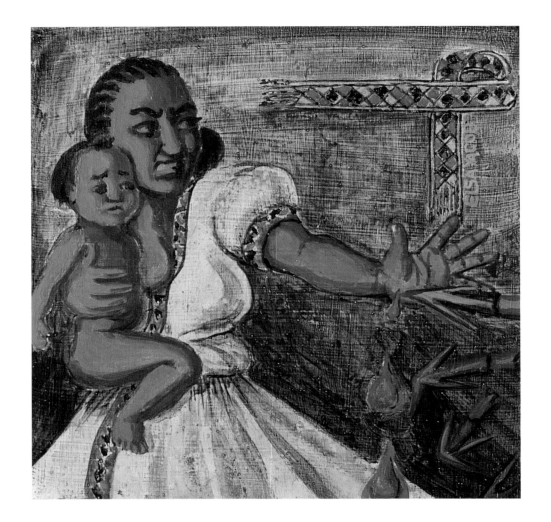

ELSA YACOB TEMNEWO (B. 1961)

I love my work; it makes me more aware when I talk with my mind and share it with others.

When she was sixteen, Elsa Yacob Temnewo joined the Eritrean People's Liberation Front to free her country from Ethiopian colonialism. In the fine arts branch of EPLF, she produced paintings, illustrations, posters, drawings, sculptures, and caricatures. Temnewo has participated in thirteen solo and group exhibitions. From 1996 to 1999 she organized and helped judge exhibitions in Asmara. From 1991 to 1993, she was an artist in the Department of Information and Culture. Today she teaches art and trains elementary school teachers at the Asmara School of Arts. She is married and has three children.

KATRIN PERE

SANGEETA SINGH (B. 1974)

This is my deconstruction of patriarchal perceptions of a "good woman." I refuse to tolerate women being carved into something acceptable to everyone but ourselves. Painting gives me freedom to resist invisibility—socially, sexually, and politically.

Sangeeta Singh's ancestors came from Bihar, India; she is a third-generation Fijian. She started painting in 1997 at the University of the South Pacific's Oceania Centre for Arts and Culture. Sangeeta Singh lives with her partner, Luisa. She has an older sister, Rowena; her younger sister, Rukshana, committed suicide in 1995.

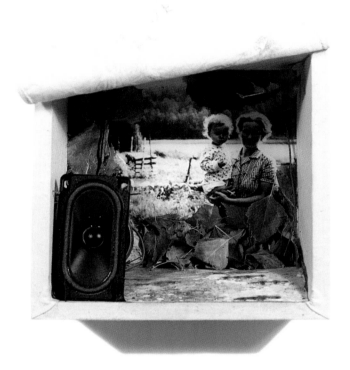

TUIRE LAMPILA

Look inside expresses the roles of a mother and a daughter. The outside view represents the impersonal wideness of the world. Lucas Cranach's rider is heading for the unknown. The inner view is personal and enclosing: an elderly woman performs a Finnish sauna-song. A mother wishes her children will be spared from the world's coldness. This wish is expressed through the repeating melody rather than the words. Obviously, the mother's wish is seldom fulfilled.

CHARLETTE CUGAT-GALANO

It is not sufficient to accept famine, war, pollution, and suffering of women and children. We must look inside and find a way to express our anguish and hope. My voice speaks through my canvases.

Charlette Cugat-Galano has studied life drawing, design, and fine arts. During the past twenty years, she has taught art in a variety of situations. Her work has appeared in exhibitions in her country and in Washington, D.C. She lives in Béziers and is the mother of three daughters.

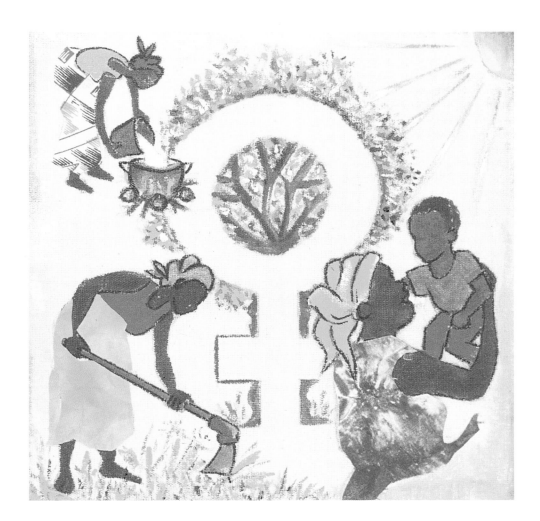

RUTH AJOLLA CARROL (B. 1959)

This painting and collage depicts women at work and doing chores at home. People do not realize that God created men and women to be equal but different. God created us differently to complement one another in all parts of life.

Illustrator and designer Ruth Ajolla Carrol has participated in group and individual exhibitions in Gambia, Senegal, France, and Japan. Carrol has won awards in national and international art competitions. Her work has appeared in books, posters, stickers, T-shirts, and Christmas cards.

SOFIA KUPZASHIVILI

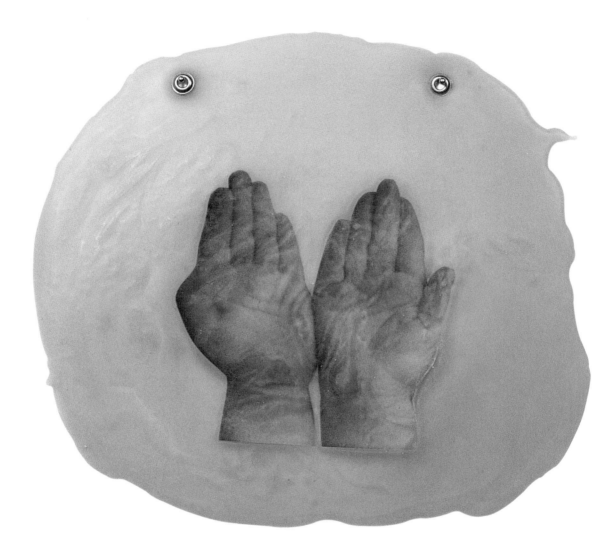

CLAUDIA TERSTAPPEN

The hands in my work deal with Japanese superstition. The lines reveal prints of images and can show our destiny. Hands are involved in everything we do; they transfer information into us.

MAUREEN HAZELLE AND VIRGINIA TYLER

This piece is a collaboration between Maureen Hazelle from Ghana, West Africa, and Virginia Tyler from the United States. Hazelle's contemporary painting on damask is based on traditional embroidery designs for women's clothing. Tyler's frame depicts women's faces modeled in traditional West African patterns.

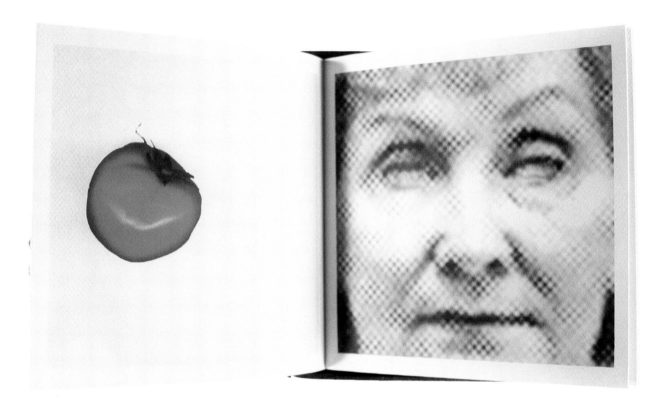

DESPINA MEIRAMOGLOU (B. 1944)

Violence in politics and everyday life is the issue that most occupies my mind. I collect clippings about crimes and violent acts to use as outlines in my projects. I use the digital processing of the image, whether from my digital photos, media images, or scanned objects, as a weapon to alter reality. It builds my version of reality: sarcastic, sometimes biting, but always filled with my threats and desires.

Despina Meiramoglou is a graphic artist in the advertising field. Since 1981 she has had nineteen solo shows in Athens and abroad. Her work has appeared in group shows in Greece and abroad. Since 1992 she has produced ten limited-edition art books; most are represented by Printed Matter Bookstore in New York.

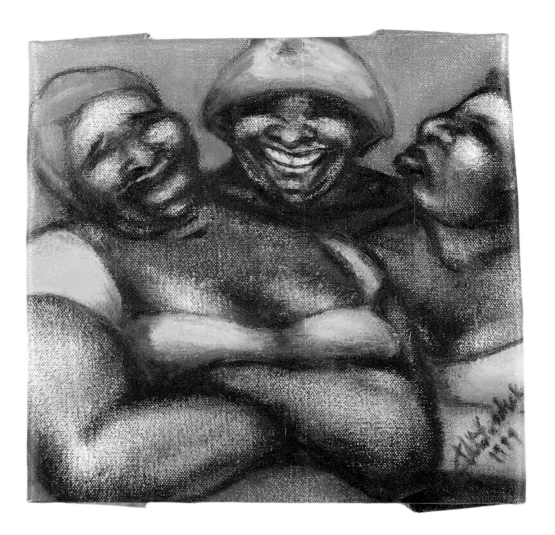

CHRISTINE MATUSCHEK (B. 1955)

I look at human nature
With a twinkle in my eyes
Bright and bold plasticity
Captures the observer
Reading between the lines,
Caught in the middle, a smile or laughter
 is my reward

Born in Germany, Christine Matuschek now lives in Grenada. Matuschek has participated in exhibitions in Grenada, the Dominican Republic, the United States, and Barbados.

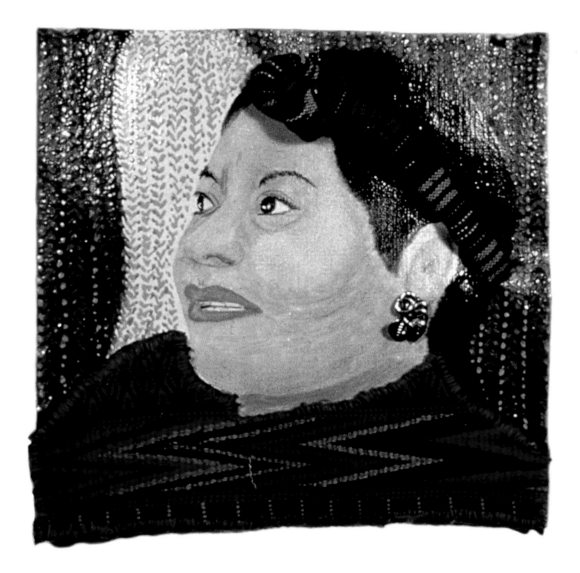

MYRIAM KHUN

I represent Rigoberta Menchú, the Guatemalan woman who fights for peace, human rights, and native communities' rights. Menchú won the Nobel peace prize in 1992.

Born in Guatemala, Myriam Khun lives in New York. A self-taught artist, she makes jewelry out of silver, precious stones, and semiprecious stones from around the world.

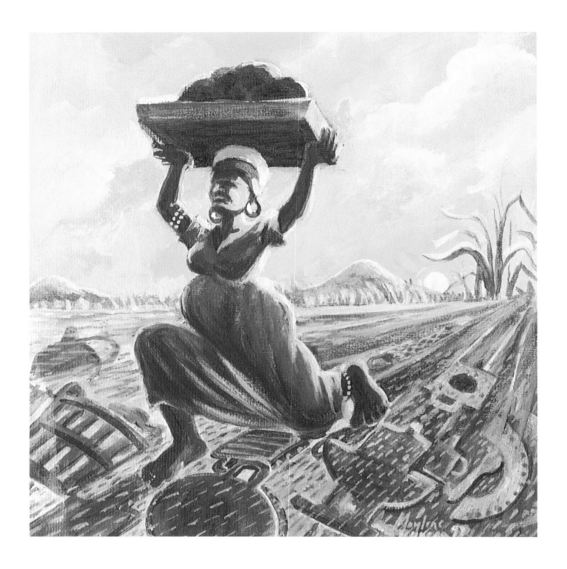

MAYLENE DUNCAN (B. 1960)

This painting symbolizes woman's beauty, strength, and remarkable versatility. The tapestry represents the earth, which contains symbols of woman's labor. The woman rises from the earth with irrefutable power.

Maylene Duncan taught ceramics and drawing at the Burrowes Art School from 1986 to 1996. She also illustrates textbooks for her nation's primary schools. As a member of the Guyana Women Artists' Association, she has participated in group exhibitions in Guyana, Barbados, England, and Canada.

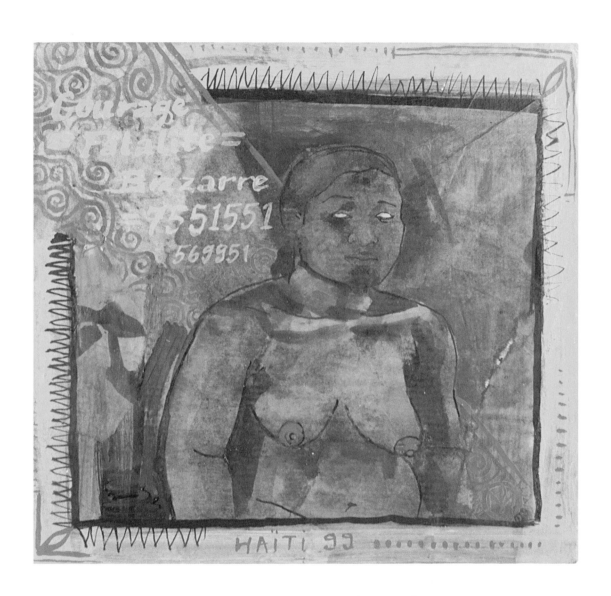

PASCALE MONNIN (B. 1974)

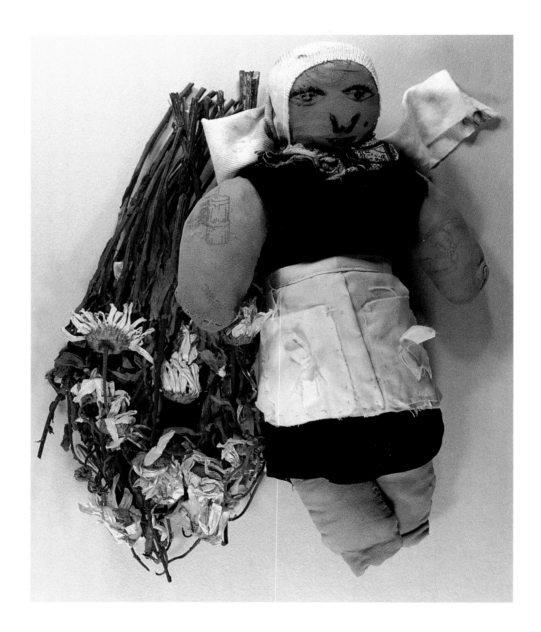

XENIA MEJIA

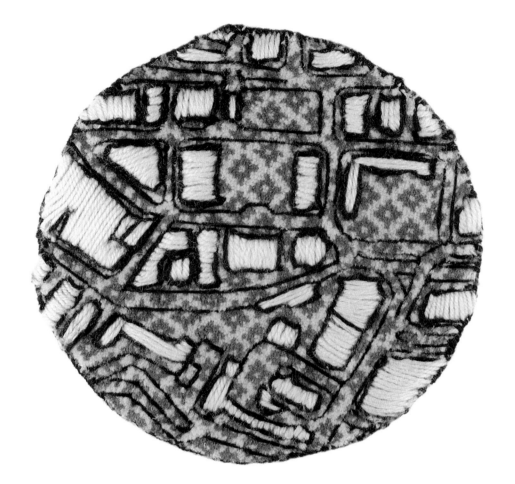

WONG CHI HANG (B. 1968)

Modern City is a series of positive objects (building blocks) and negative space (infrastructure framework and open space). Our movement within the city is directed by the road and network system. Through reading maps—a series of codes and symbols—we see an abstract city.

Wong Chi Hang, who studied architecture in Hong Kong, participates in the Studio Program of PS1 Contemporary Art Center in New York. She is a cofounder and committee member of Para/Site Space in Hong Kong, an artist-run space for visual art exhibitions, forums, and publications. She was a project grant examiner at the Hong Kong Arts Development Council and has exhibited in Germany and in Hong Kong.

GYONGYI KAMAN (B. 1970)

My work examines the relationship between the spiritual (interior) and physical (exterior) body and their permanent, continuously changing interactions.

My objects are based on illlusionism, representation, and composition, yet they also document reality. I use and even emphasize the "real" proportions and representation of the body, regardless of the medium.

Gyongyi Kaman has had four solo shows in Budapest since 1995. Her work has appeared in group exhibitions in Hungary, the Netherlands, Iceland, and Germany. Kaman has won prizes and scholarships, including the Derkovits Gyula National Fine Arts Fellowship and a scholarship to the Hungarian Academy in Rome. Her work is in public collections in Italy and Hungary.

SOFFIA SAEMUNDSDOTTIR (B. 1965)

Bird sitting on a traveler: I call my figures *travelers.* They wear an undetermined national costume and fly around the world singing and searching, perhaps for the perfect place. The traveler in this piece stands by a big waterfall that drips on his face. The power of the waterfall is tremendous; the earth shakes under the traveler's feet. The bird on his head, however, sits still. The bird is like a woman because it represents power and eternity, yet also peacefulness.

Soffia Saemundsdottir lives in Iceland. She studied at the Icelandic Art School, and has had solo shows and group exhibitions since 1995.

JHUMKA GUPTA

A woman can be as subtle as water, as raging as fire, as fruitful as the earth, or as encompassing as air. The Hindu goddess Durga symbolizes strength. Her many arms and third eye represent divine feminine power. The objects she holds illustrate aspects of femininity.

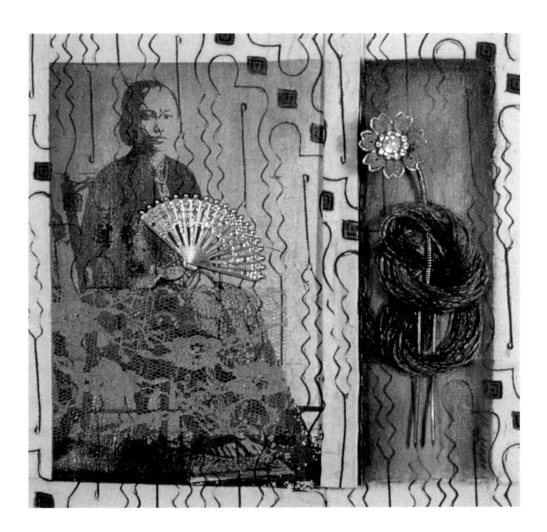

ASTARI RASJID

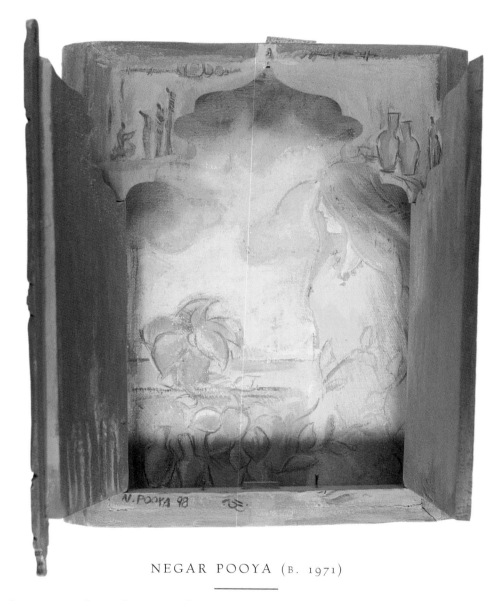

NEGAR POOYA (B. 1971)

My work is in a traditional mirror's frame, since in our culture the mirror is a sign of purity. I have tried to visualize the spirit of a woman.

Negar Pooya has participated in painting and printmaking exhibitions in Iran, Romania, and Japan. She has worked in print and TV advertising. She lives in Canada with her husband, also an artist, and works on web designs.

SUAD AL-ATTAR

My paintings are archives of my emotions that stem from dreams, myths, sensuality, and taboos. Each painting is a mirage of birth or death. I want my paintings to trigger passion, fear, and mystery.

Suad Al-Attar lives in London. She has had solo shows in London, Los Angeles, Baghdad, Beirut, Paris, Kuwait, and Washington, D.C., and has participated in group exhibitions throughout the world. Her work is in private and public collections. Among her prizes is the gold medal and first prize of the International Biennial of Cairo in 1984. UNICEF New Year's cards featured her work in 1975 and 1993.

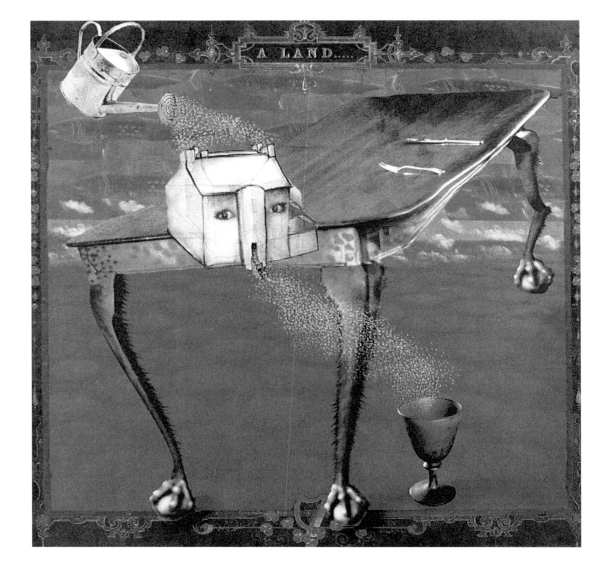

ANDREA HALPIN (B. 1971)

Website designer Andrea Halpin has been in two group shows in Cork.

MARGALIT MANNOR (B. 1940)

My art focuses on subtle phenomena.

Photographer Margalit Mannor's work is in the Israel Museum, the Tel Aviv Museum, and the Brooklyn Museum, among others. She is married with four children.

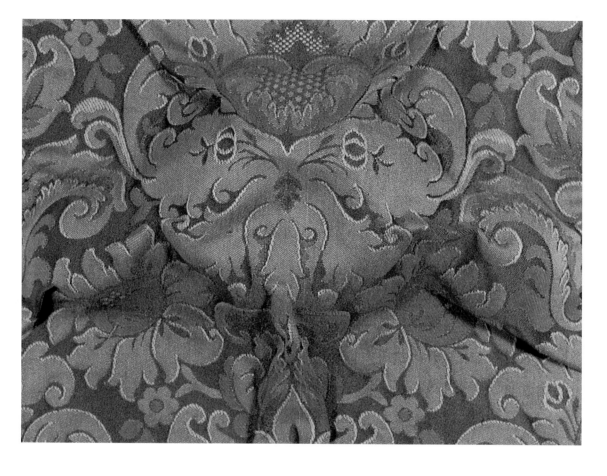

ELENA BERRIOLO (B. 1959)

The concave fold of any life-form, whether open or protected by more folds, defines the feminine being. The concave fold is an immobile cavity that shows its beginnings as it unfolds and offers itself.

Born in Italy, Elena Berriolo now lives in New York. During the 1990s her work was in the Venice Biennial, the Pecei Museum, and Studio Marconi, Italy; the Ludwig Forum and Kunstpalast, Germany; Artists' Space, New York; Centro Cultural la Beneficencia, Spain; and the Artist Museum, Israel. She is participating in "Construction in Process VII" in Poland, June 2000.

PETRONA MORRISON

My work explores women as strong, powerful survivors yet also vulnerable, fragile, and fragmented.

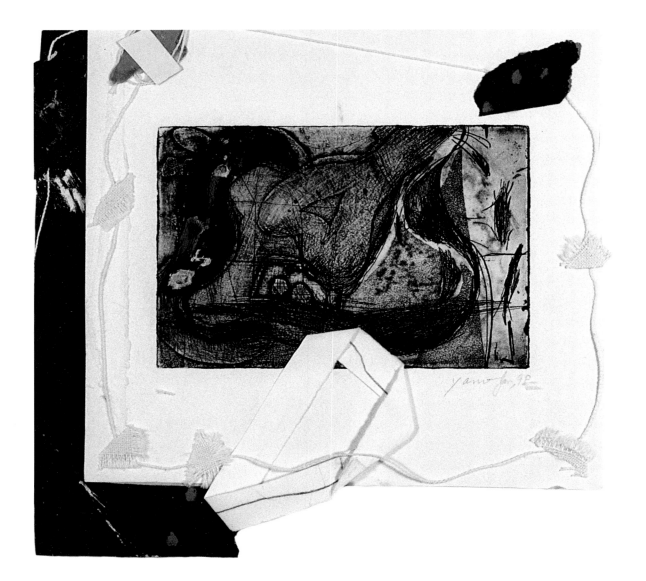

NORIKO YANO

Composition and colors harmonize in my painting. I represent women as strong, energetic, creative, mysterious, and positive.

RIHAM GAHSSIB

This painting is called *The Honor Killing*. Another century has ended, yet women are still subjected to torture, suffering, oppression, abuse, and honor killings.

Although she has a profound appreciation for abstract and contemporary art, Riham Gahssib seeks to forge a new style rooted in Jordanian life. She has exhibited in Jordan, the United States, and Europe.

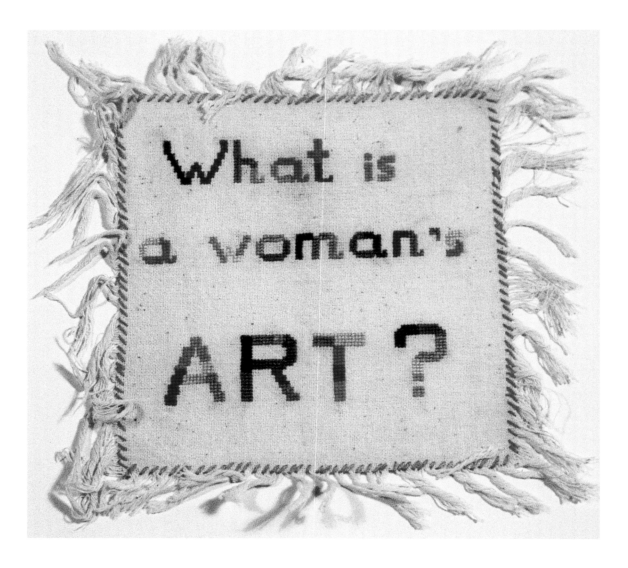

YELENA VOROBJEVA (B. 1959)

I work with real things to show their magical qualities.

Since 1988, Yelena Vorobjeva has participated in group exhibitions in her country. She is a painter, a graphic designer, a curator, and an author.

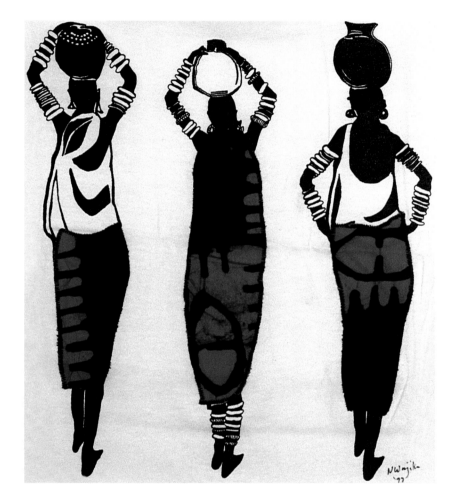

NAOMI WANJIKU

Kenyan women have many burdens to carry, yet we walk tall.

Naomi Wanjiku grew up in Kenya, immersed in local art. She helped her grandmother create beautiful baskets; her neighbors design, build, and color their homes; and local weavers make clothes. Today she merges contemporary Western techniques with traditional African techniques. She is the president and creative director of Wanjiku Designs, Dallas.

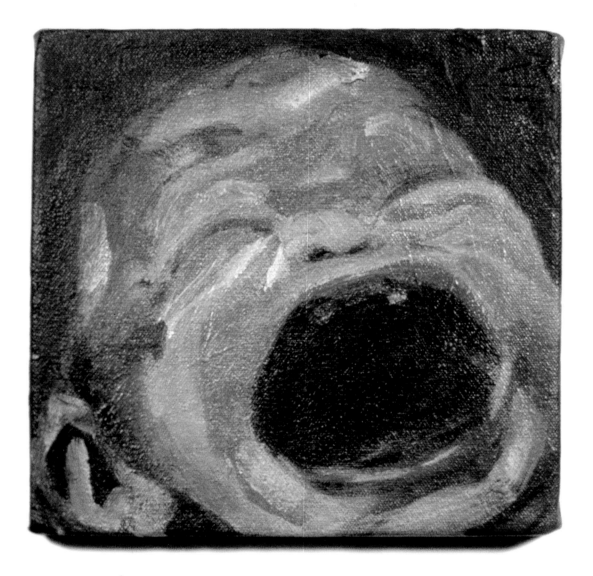

SUMITA KIM

There is a big, burning hole in my heart. Whenever worries and anxieties seep into my mind, I bundle them into tight balls and throw them into the flames. This transformative process is at the core of my spiritual and artistic practices.

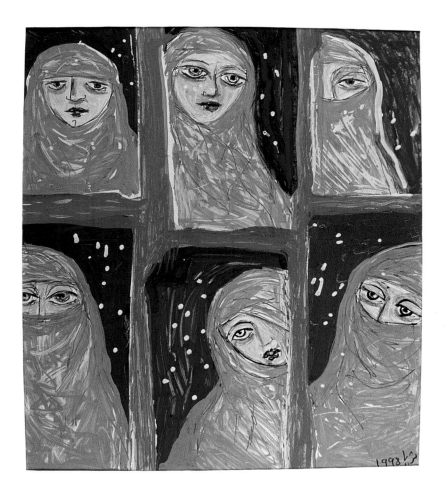

THURAYA AL-BAQSAMI

In *Waiting*, six Kuwaiti women hope for the return of their husbands, sons, and brothers who were taken hostage during the brutal Iraqi invasion of Kuwait in 1990. The women reflect sadness, worry, anger, and confusion. The white spots in the background are the women's dreams. Their light blue clothes are typical of what women wear when they pray. Light blue also represents innocence.

Thuraya Al-Baqsami is a journalist and an illustrator in Kuwait. She has written short stories, children's books, and art criticism. She has had thirty-three solo shows, and has been in fifty group exhibitions, international biennials, youth festivals, and women conferences in such cities as Washington, D.C., Beijing, Cairo, Moscow, London, and Paris. She has won prizes, including the Golden Palm Leaf from the GCC Biennial in Riyadh (Saudi Arabia).

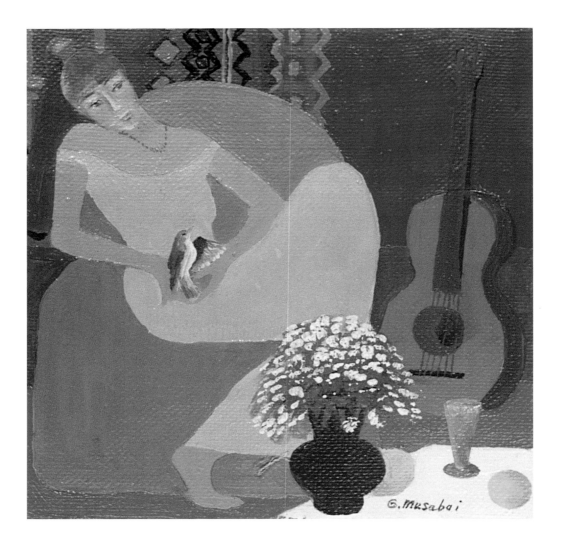

GULNARA MUSABAI (B. 1954)

Without culture, society is harsh and soulless.

Art teacher Gulnara Musabai is president of a nongovernmental organization, the League of Women of Creative Initiatives. She has participated in international and regional exhibitions. Her work is in museums and in private collections. She received the USSR Ministry of Culture's honorable award for fruitful work in 1989; the Kyrgyzstan Ministry of Culture's prize for best artwork in 1990 and 1996; and a Memorable Medal in the International Art Biennial in Bangladesh in 1997.

ANONYMOUS

The Embassy of Laos donated this anonymous piece.

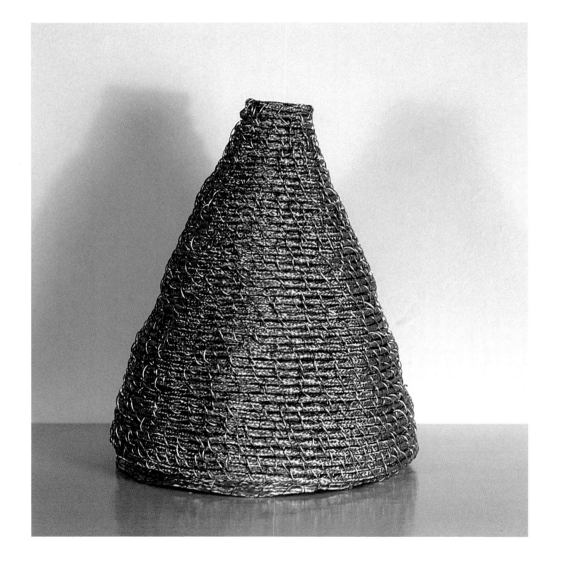

ZAIGA PUTRAMA

We are like funnels, only TWO is something complete.

AMAL MOKAREM

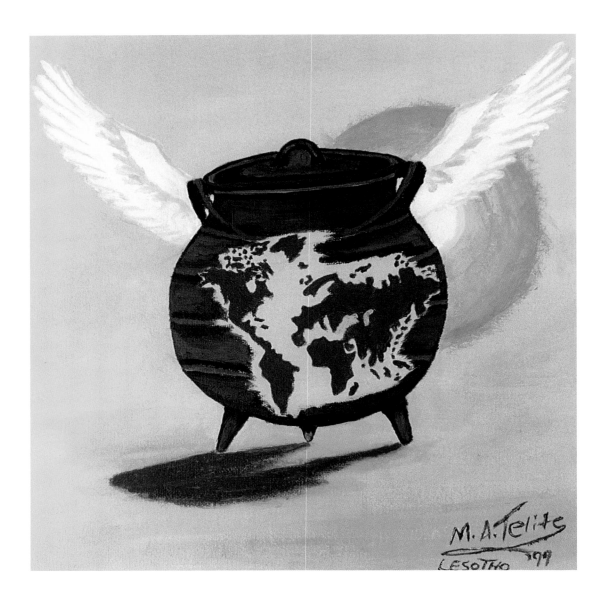

MASEABATA TELITE

CECELIA KING (B. 1953)

The design and patterns represent a woman's roles. Her eyes are shut because she sees the world through her mind's eye and interacts with it through her heart. Her mouth is closed because she has to move quietly. The world does not consider talkative women beautiful, so she has to have quiet strength. The figure in the hair symbolizes a woman's desire for freedom.

Cecelia King has forged a style without formal training. Her surrealistic lithographs are in galleries and private homes around the world.

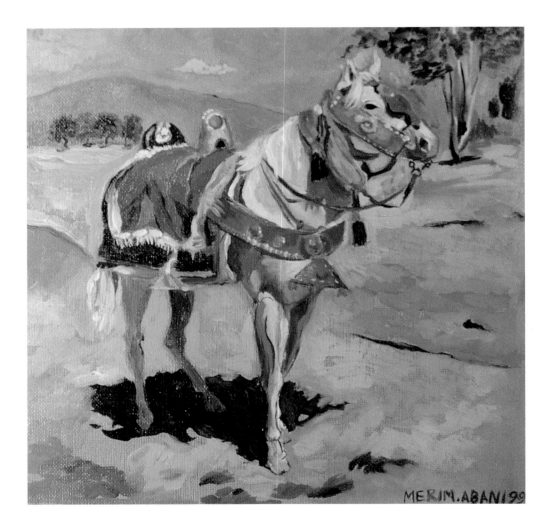

MERIM ABANI

Art is a place
Place is environment
Environment is motivation
Motivation is artwork.

Born in Tripoli in 1973, Merim Abani graduated from the National Art Academy in 1995 and had her first solo show at Gallery de Villa in 1996. She has participated in many joint exhibitions in Libya and beyond. Abani's work falls somewhere between observing nature and experimenting with traditional forms. She depicts her subjects in a traditional way, but image and message are not the same thing.

ELISABETH KAUFMAN-BUCHEL (B. 1954)

Elisabeth Kaufman-Buchel supervises kindergarten teachers. She has had solo shows in Liechtenstein, Switzerland, Austria, Germany, Luxembourg, and France since 1988.

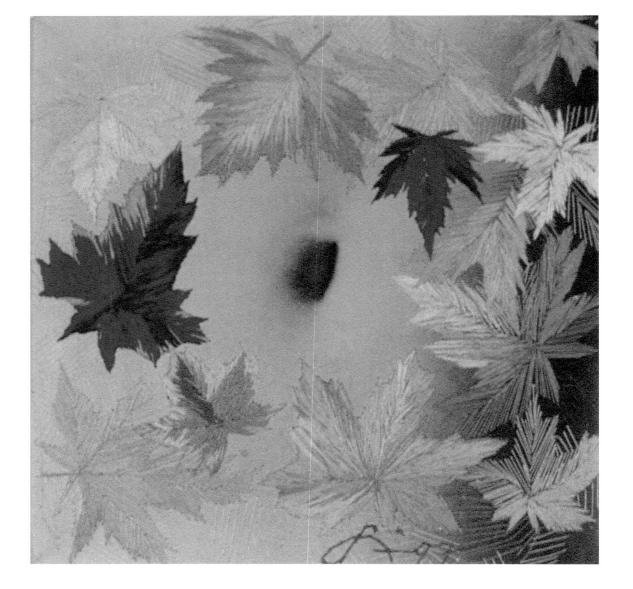

LINA JONIKIENE (B. 1969)

Lina Jonikiene has participated in group exhibitions around the world. She won an award in the Fifth International Textile Competition of Kyoto in 1997.

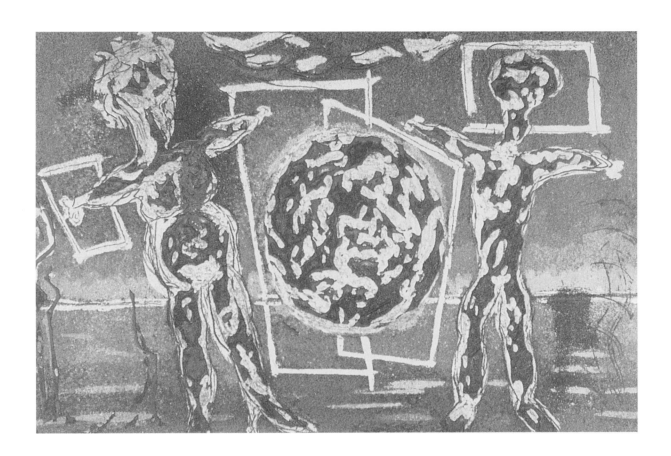

YVONNE RODESCH (B. 1959)

My etchings illustrate the isolated and excluded individual.

Yvonne Rodesch is a civil engineer who has visited museums and studied architecture throughout the world. Trained as an etcher, she has been in group exhibitions in Luxembourg and Germany.

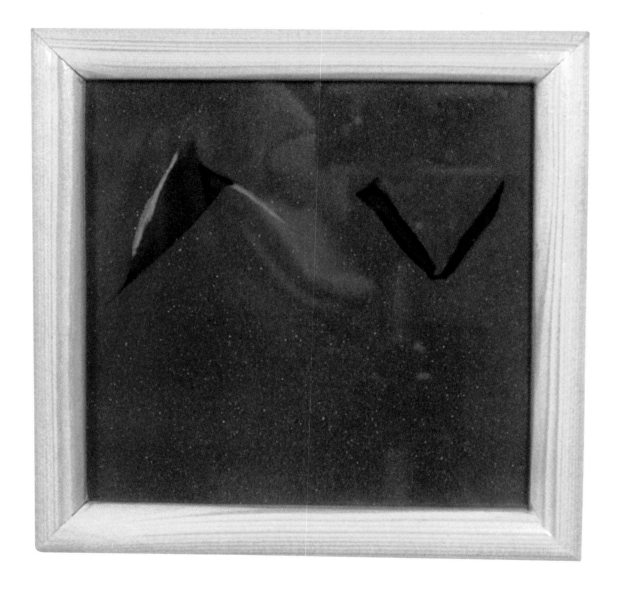

MONIKA MOTESKA

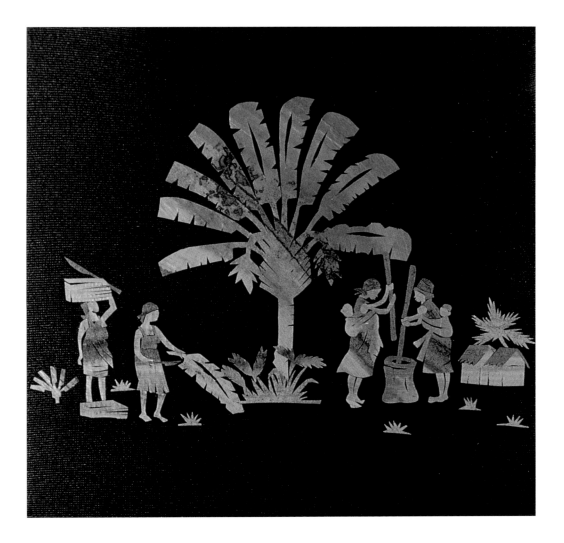

MAMIALISOA RAZANAMARO

This shows the daily life of rural Malagasy women. It illustrates the complex, intense, and dignified responsibilities entrusted to rural women, including raising children, preparing food, managing family unity, and protecting the environment.

Mamialisoa Razanamaro is a museum curator and the regional supervisor of the Life, Food, and Women project. She works with various handicraft forms and techniques and teaches preservation and restoration of artwork.

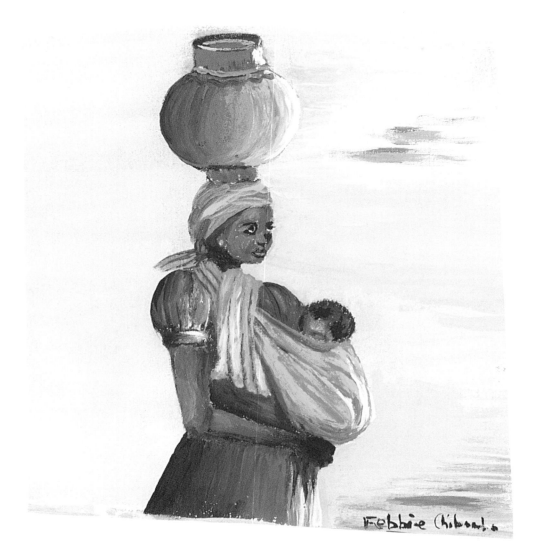

FEBBIE CHIBAMBO

Febbie Chibambo is a lecturer of art education at the University of Malawi and a multiple prizewinner in graphic-arts competitions.

JUN-ANN LAM (B. 1965)

Loss of ethnic identity results from the inevitable assimilation to an adopted environment. A new identity can be gained, however, through reinforcing ethnicity in domestic life.

Born in Kuala Lumpur, Jun-Ann Lam now lives with her husband in Melbourne, Australia. She makes installations at her home studio and is a freelance graphic designer.

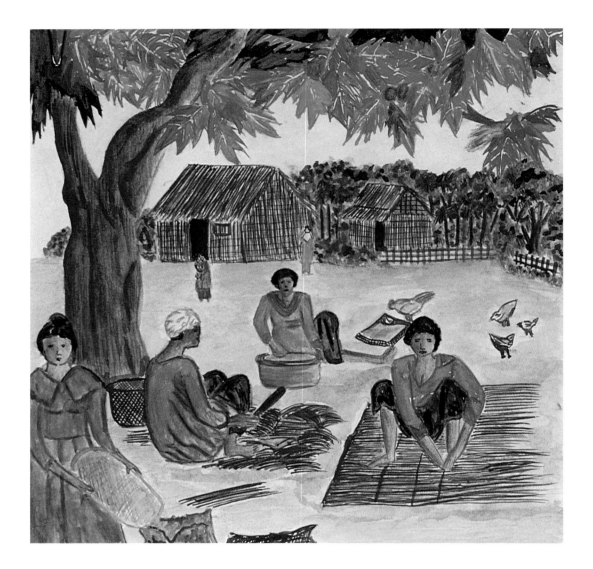

MISS FATHMATH SHIRAANI (B. 1980)

As a star appearing from the darkness, women bring brightness to our future.

Fathmath Shiraani has participated in judged exhibitions. Among her awards was first prize in the Health Day Exhibition. She wants to be a primary school teacher to help children explore the colors of nature.

NENE THIAM (B. 1952)

Nene Thiam abandoned her training in modern painting to work in an ancestral technique. Bogolan (mud cloth) uses dyes from leaves, bark clay, and handwoven cotton cloth. Thiam is interested in ancestral Malian and African symbols. She teaches tourism at the National Institute of Arts in Bamako. She is also a member of Group Bogolan Kasobane: six painters who have worked together for more than twenty years. Her work has been exhibited in Africa, Europe, Asia, and America.

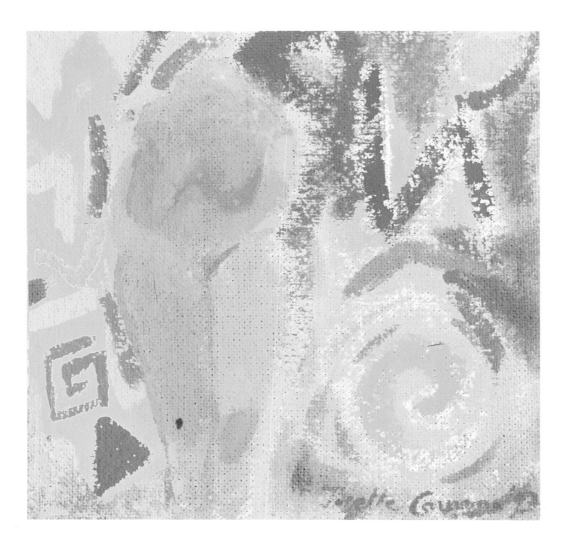

JOSETTE CARUANA (B. 1959)

This work is inspired by my heritage and symbolizes Venus. Making art represents a magical birth in which the spirit of beauty completes the vitality of nature.

Josette Caruana has had solo exhibitions in Malta and Italy and has participated in group exhibitions and symposia in Malta, Italy, Belgium, Germany, Austria, and the United States. Her work is in collections in Malta and abroad, including the Maltese State Museum.

JOLOK LEON

ANONYMOUS

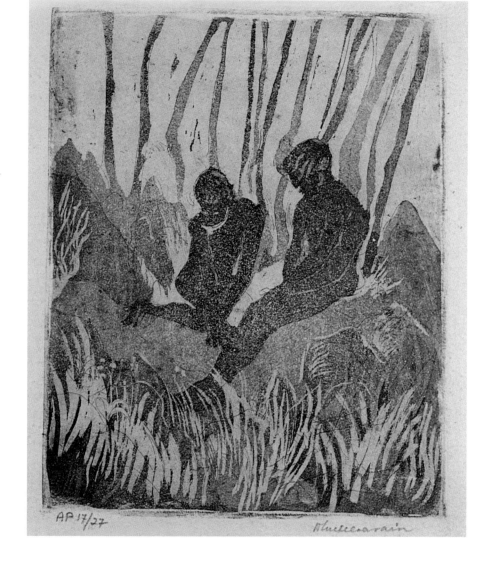

NEERMALA LUCKEENARAIN

The themes in my artwork are reincarnation, signs, and symbols from Hindu mythology.

Neermala Luckeenarain does etchings, woodcuttings, and drypoint. She teaches printmaking at the Mahatma Gandhi Institute. Luckeenarain has participated in printmaking exhibitions and has published articles and poems. Her exhibition on the life and philosophy of Buddha toured Mauritius for six months.

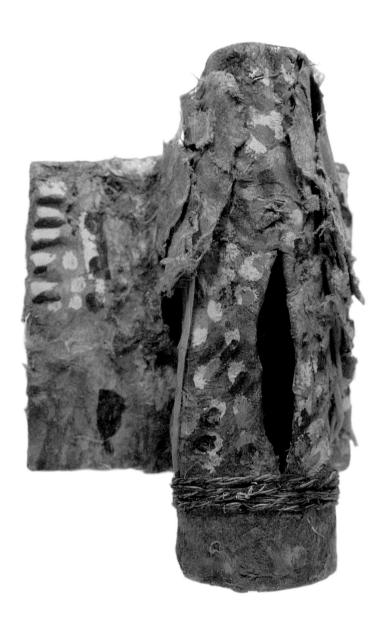

MARTA PALAU

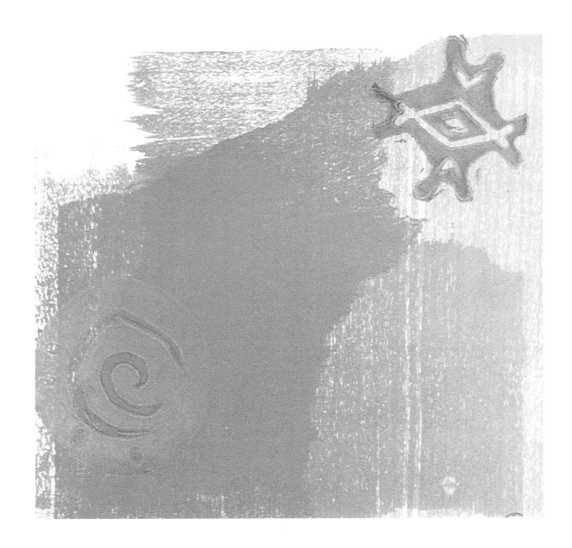

ELENA GARSHTEA (B. 1961)

Elena Garshtea teaches drawing, watercolor, and lithography at the Moldavian Art Institute. She has been in exhibitions in Moldova, Germany, Russia, the Czech Republic, Poland, Romania, France, Belgium, Hungary, the United States, and Argentina.

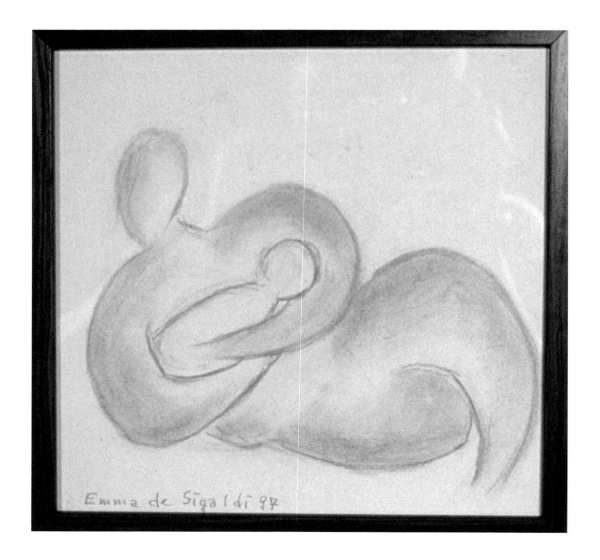

EMMA DE SIGALDI (B. 1918)

Emma de Sigaldi, a former dancer, has had solo exhibitions internationally. Her giant sculptures adorn many public places. Her work is in private and public collections in Monaco, Peru, Switzerland, and elsewhere.

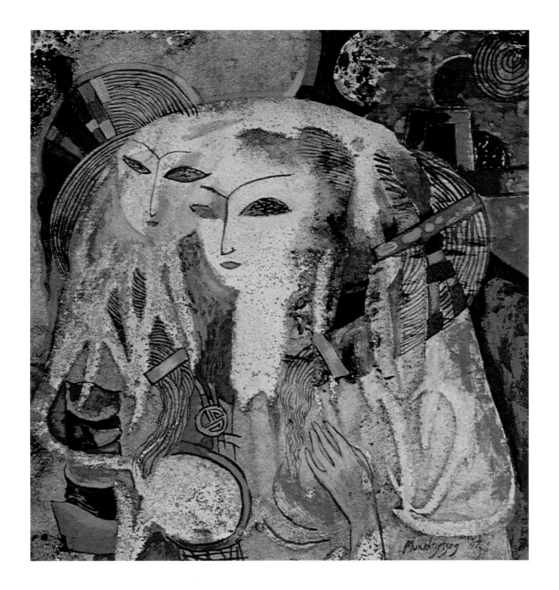

JALKHAAJAVYN MUNKHTSETSEG (B. 1967)

It is said that art starts where truth goes away. But I think it is meaningless to distinguish between truth and lies.

The Mongolian Artists' Union presented Jalkhaajavyn Munkhtsetseg with the "best artist" award in 1995. Her exhibition in 1999 was called "Dream of Aquarius." She lives with her husband, also a painter, and her son. Together they produce contemporary Mongolian paintings.

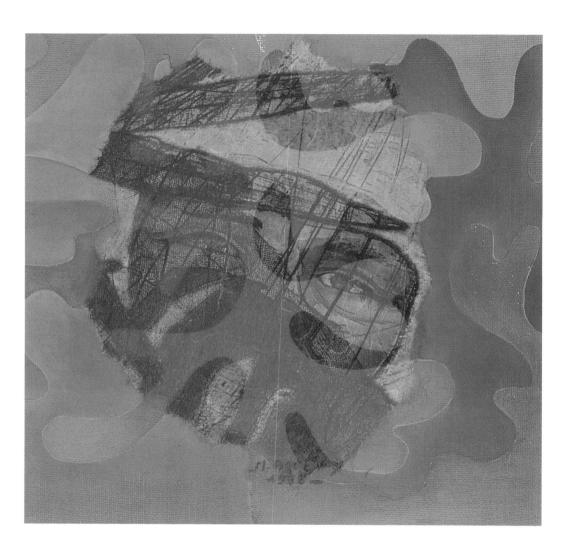

MALIKA AGUEZNAY (B. 1938)

The themes in most of my paintings and etchings are about women because they create the magic and mystery of life. A woman's sensibility and intuition are her driving strengths.

Painter and printmaker Malika Agueznay has had solo exhibitions in Morocco since 1978. Agueznay is inspired by seaweed. She has participated in exhibitions in France, Spain, Egypt, Poland, the Netherlands, Japan, Greece, England, and the United States.

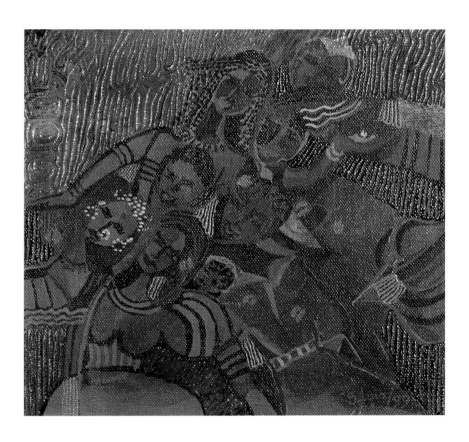

SILVIA DO ROSARIO DA SILVEIRA BRAGANCA (B. 1937)

Soprano winds
lead navigators
in their own boats
from the two shores
emotions and feelings cross each other
men and women unite in passion
on one side and the other Mozambique . . . India . . .

*For the past thirty-five years, Silvia do Rosario da Silveira Braganca has taught art and art history in
Mozambique, Portugal, and Goa, India. She has participated in art symposia in Brazil, Finland, Portugal, and
Japan. Her work has appeared in solo and group exhibitions in Mozambique, Portugal, India, Angola, Spain,
and Romania, and it is in national and international museums and private collections.*

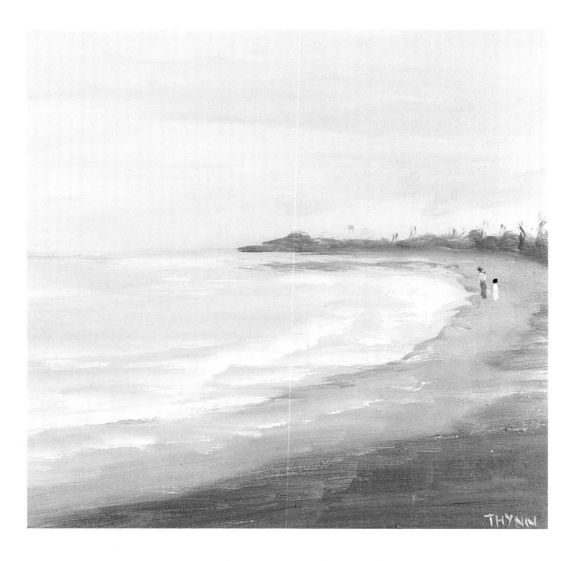

ZEYAR THYNN (B. 1944)

Sharing art is sharing love. Myanmar women, like all women, love and care for living beings, especially their children.

Zeyar Thynn and her husband founded the Golden Valley Art Centre, which has featured her work. She has also participated in exhibitions in Australia and Thailand.

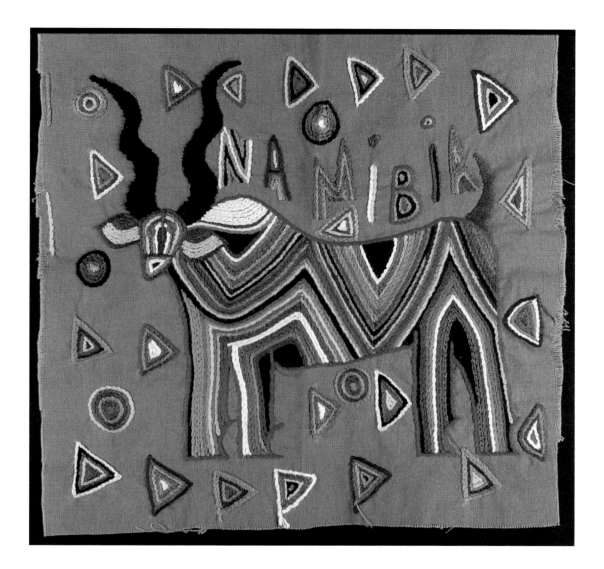

THABEA MATHEUS

Thabea Matheus is one of around four hundred women who make colorful embroidery for the art cooperative 'Ikhoba. They produce colorful embroidered wall hangings, tablecloths, and other goods. The traditional designs depict scenes from daily life, such as brightly colored washing on the line, wild animals, birds, children, and huts. 'Ikhoba exhibits regularly in Europe.

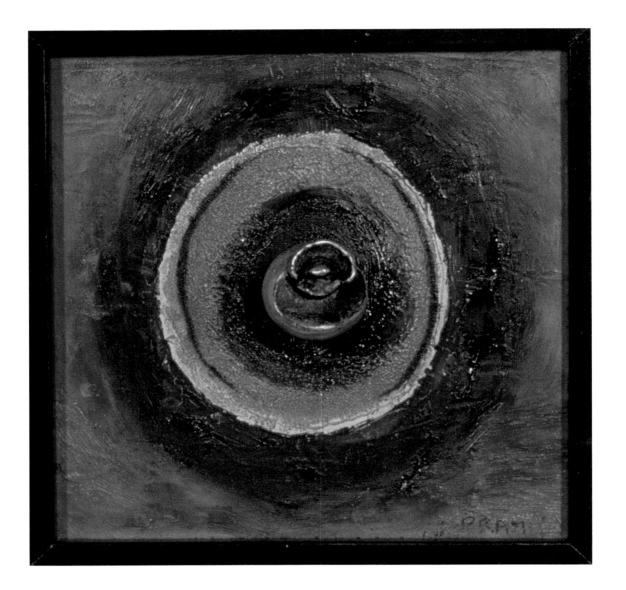

PRAMILI GIRI

Nature is my main inspiration. Through my work I want to contribute to the development of my country. I also wish to promote the role of contemporary fine art in Nepal. As artists, we must listen to inside forces, and not to superficial trends.

Pramili Giri has had solo shows in the United States, Nepal, India, and Norway. She has also completed public commissions in her country.

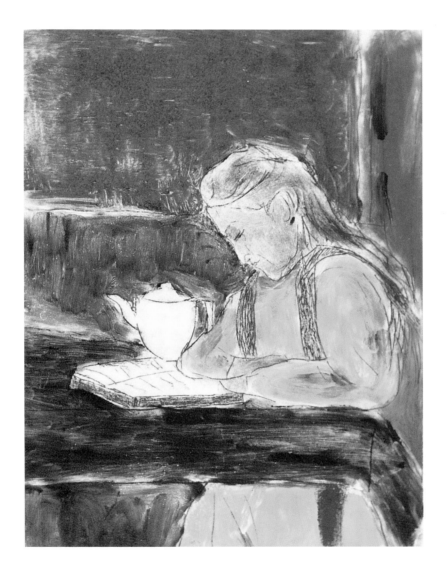

KLARA KUIPER (B. 1957)

I hope those who see my work understand what I felt when I saw my subject. It can be the feeling when I saw the colors of a landscape in the late-afternoon sunshine, beautiful African woman in their colorful clothes, or a clumsy little bird that made me laugh.

Klara Kuiper is a lawyer. Her art has appeared in nine exhibitions in Japan and the Netherlands.

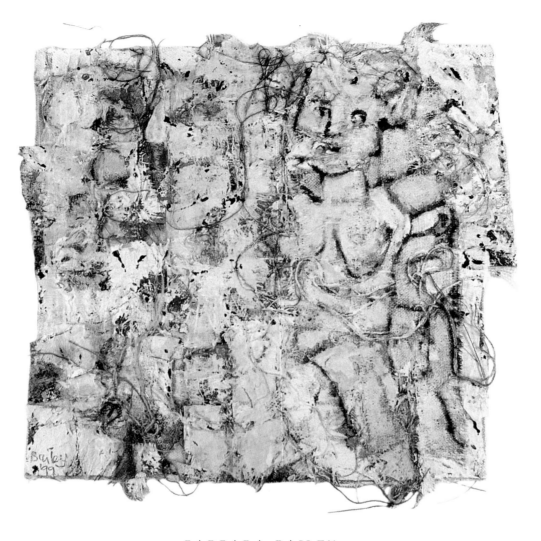

BARBARA BAILEY

Aotearoa Women is about the rich texture of women's lives. Threads in the painting symbolize the ties that bind women's experiences. In rural New Zealand there is a woman who seems tough. She digs holes for posts, rounds up sheep, drives a truck, and rides horses. As a partner in the family farm, she does the books, cooks for shearing teams, and often runs her own business on the side to make ends meet. At the drop of a hat she will bake scones and roast meat. She is a strong woman with capable hands. Often you can see in her face traces of Maori and Pakeha ancestry.

Barbara Bailey's paintings have appeared in solo and group shows in New Zealand and overseas. As a fashion designer, Bailey explores her love of textiles in her work. Her canvases are often overlaid with fine cottons and wool. She pulls threads and forms layers of stitched and painted canvases.

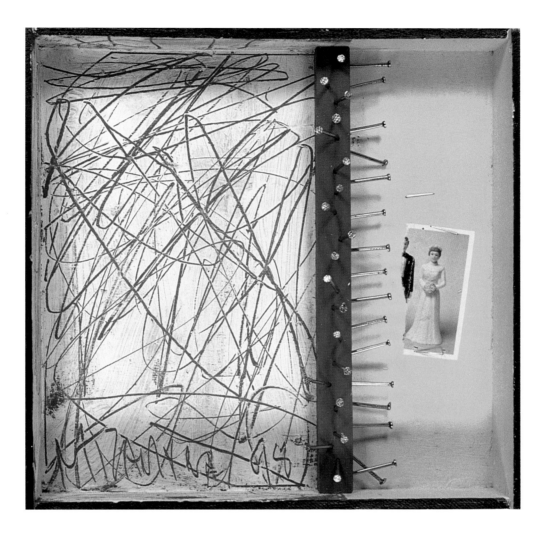

MARIA JOSÉ ZAMORA (B. 1962)

The red and white side of this piece means the life of contradictions: the fights and problems most women deal with every day. The red wood with nails symbolizes women's hurt feelings; each nail represents women's suffering due to emotional and physical abuse. The yellow part, showing a bride without a groom, represents the ideal marriage: virginity and the strong social and cultural pressures on women. The box of cigars, intended for men, was most likely made by an impoverished woman.

Maria José Zamora was born in Nicaragua and was forced to leave in 1983. Her painting is a commitment to gain a place as an individual, regardless of gender and cultural biases. Today she is pursuing a career in psychology and lives in Managua.

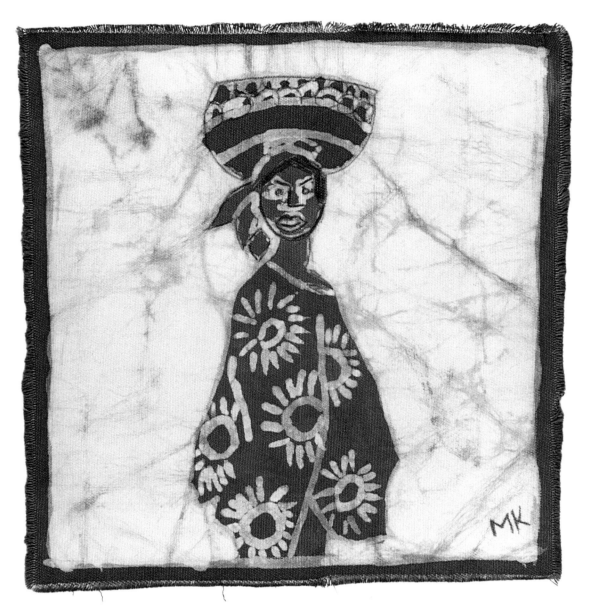

MARIE KAZIENDE (B. 1964)

Marie Kaziende makes watercolors on canvas and batiks. They show African women doing household activities and other aspects of daily life. She has worked in textile designs and has organized expositions in West Africa.

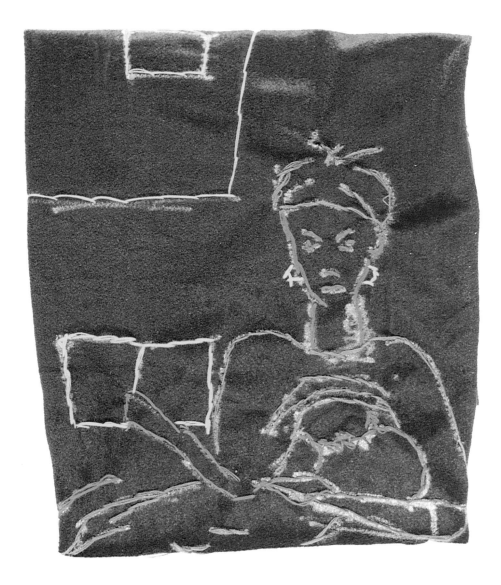

CHRIS FUNKE IFETA (B. 1955)

Women are very resourceful and should be encouraged to learn skills. If given the opportunity they can do just as well as men. I have worked hard to prove this.

Sculptor Chris Funke Ifeta is the national president of the Society of Nigerian Artists and an art lecturer.

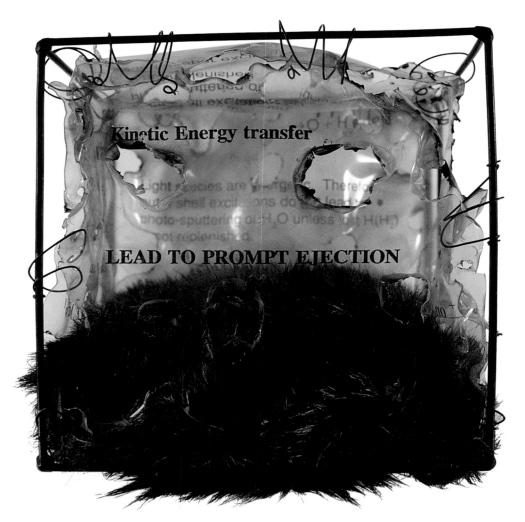

The text shown in the artwork reads: "Kinetic Energy transfer" and "LEAD TO PROMPT EJECTION"

BARBARA MAC CALLUM (B. 1942)

My work deals with the creative process in science and art. It evolves through a collaborative relationship with my husband, a physicist: I recycle his published papers and transparencies.

Barbara Mac Callum has had solo shows in Lima, Washington, D.C., New York City, Virginia, and Honolulu. She has received grants and is an art professor at Piedmont (Virginia) Community College.

LINE WAELGAARD

NADIRA MAHMOUD AL LAWATIA

Born in Muscat, Sultanate of Oman, Nadira Mahmoud Al Lawatia studied law and worked in that field for some years. She later dedicated herself to painting and the management of her own Oman Art Gallery, which she established in 1993.

She has participated in numerous solo and group exhibitions; her work has been shown in Oman, Syria, Kuwait, Bahrain, Egypt, the United States, and many European countries, and is widely collected. Her honors include a Bicentennial Kuwait award (1996) and a third-place award from the Second Biennial Muscat (1990).

NAIZA H. KAHN

I use the female body as a metaphor of cultural and psychological concepts and as a means of expressing identity. In the series "Nine Parts of Desire," words suggest the presence of the body, particularly bodily sensations linked to emotional states.

Since 1987, Naiza H. Kahn has exhibited in England, Pakistan, and Hong Kong. Various publications have reviewed her work.

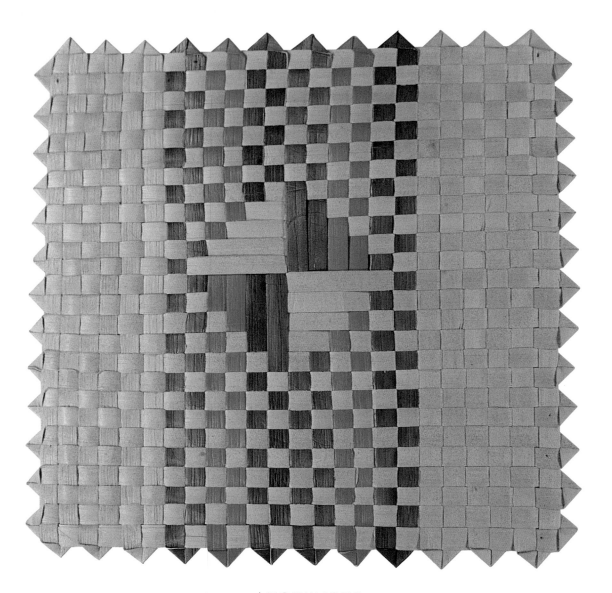

ANONYMOUS

Echedoll—mats woven from pandanus leaves—are used by Palauans for canoe sails, covers and pillows for sleeping, and burial shrouds, among a great many other things. Pandanus leaves are also woven into women's belts, handbags in which to carry betelnuts, and more modern items—brassieres, placemats, and cases for eyeglasses and spectacles.

This colorful sample is meant for a woman's handbag. The pandanus leaves are dried in the sun, smoothed out, and cut to the sizes needed for weaving—which is mostly done by women.

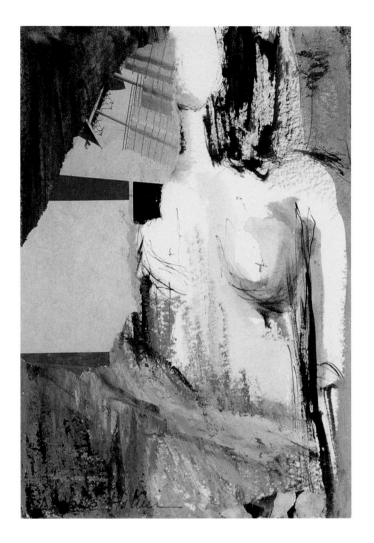

NABILA HILMI (B. 1940)

I grew up in countries that filled me with a strong sense of time, space, and history. People and places, therefore, fill the space of my work. They move in a world with no frontiers. They provoke memories of people and places, yet reflect the need to live in the moment.

Born in Jerusalem, Nabila Hilmi now lives in the United States. She exhibits internationally in solo, juried, and group shows. Her work was in "Forces of Change: Artists of the Arab World," which toured the United States for two years. She had a solo show at the Foundry Gallery in Washington, D.C., in 1999.

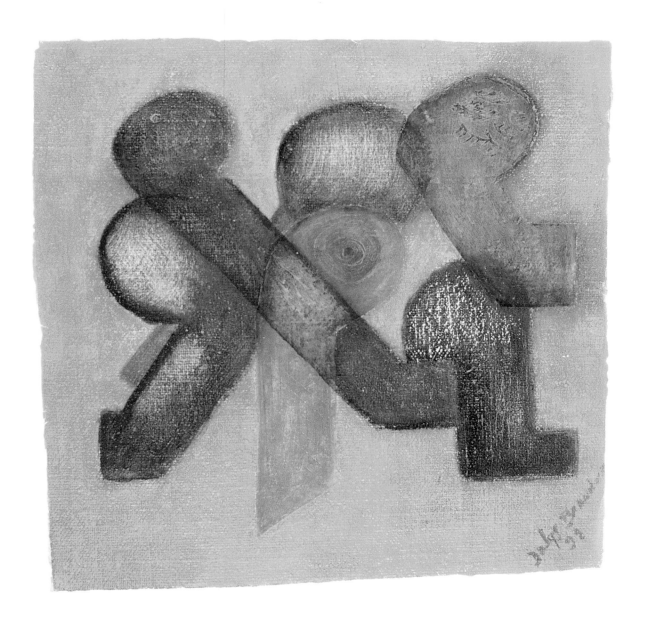

DALYS BRANDAO DE ALFU

The work is called *Women and Their Social Roles*.

Dalys Brandao de Alfu has participated in exhibitions in Panama, Japan, and the United States.

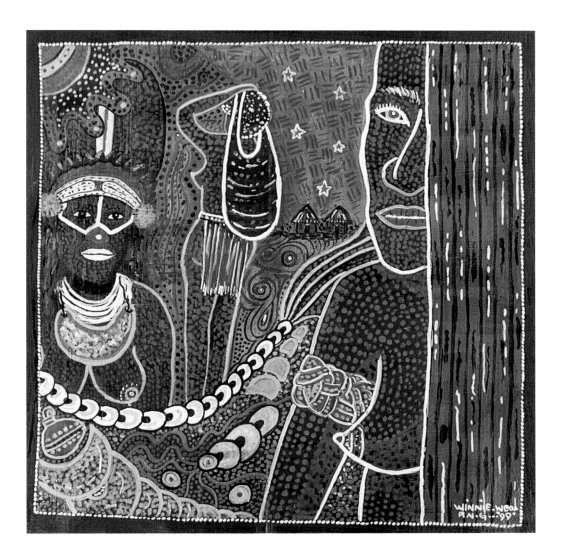

WINNIE WEOA

This shows the daily life of village women in the highlands of Papua New Guinea. Their daily household duties include tending to gardens and looking after pigs. For special occasions or ceremonies, such women are seen in traditional finery.

Winnie Weoa was born in Enga and Hagen, Highland Province. She turned to drawing and painting at an early age, realizing that her hearing and speech disabilities left her with limited opportunities. Weoa realized that she had an affinity for art, studied fine arts, and makes her living as a freelance artist.

IRMA GOROSTIAGA (25 DE MAYO 1930)

Irma Gorostiaga is a high school art teacher. Since 1987, her work has appeared in solo and group exhibitions in Paraguay and Spain. She received the first prize and gold medal at the Museum of Fine Arts, Asunción, Paraguay in 1998.

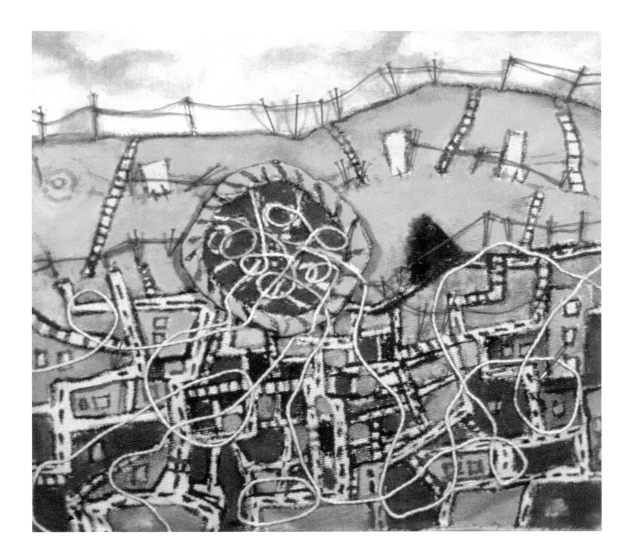

MILAGROS PONCE DE LEON (B. 1972)

My fabric represents a woman–mountain preceding Lima, the ever-changing city in the Peruvian desert. The city is a metaphor of woman: the desert has been given life and turned into a city. The woman is the silent, central force that endlessly transforms and creates.

Milagros Ponce de Leon is getting a second MFA in scene design for opera and theater. Her work has appeared in galleries and museums in Washington, D.C., Baltimore, New York, New Delhi, Cuzco, and Lima.

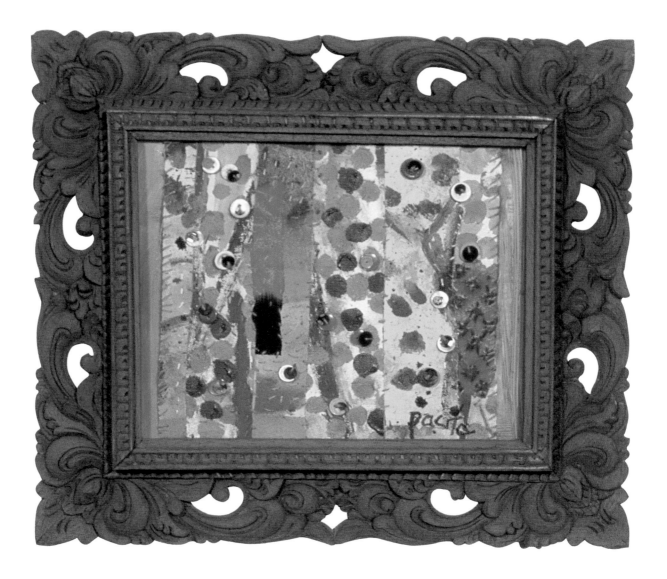

PACITA ABAD

Pacita Abad lives in Indonesia. She has exhibited in the National Museum of Women in the Arts, Washington, D.C.; Hong Kong Arts Center; the Museum of Philippine Art; the Bhirasri Institute of Modern Art, Bangkok; the National Museum of Contemporary Art, Seoul; the Second Asian Art Show, Fukuoka, Japan; La Bienal de Habana, Cuba; the Altos de Chavon, Dominican Republic; and the Bronx Museum, New York, among others. She has received a National Endowment for the Arts Visual Artist Fellowship, a New York State Council on the Arts Visiting Fellowship, and the Likha Award.

ALEKSANDRA ANNA JANIK (B. 1971)

It is not the beauty of a woman that fascinates us in paintings, but the idea of her beauty without any falseness.

Aleksandra Anna Janik has participated in exhibitions in Poland, Japan, Spain, Germany, and Hungary. She won the Sponsors' Prize at the Fourth Sapporo International Print Biennial in Japan in 1997 and the NTO prize at the Salon Jesienny in Poland in 1998. She specializes in printmaking, drawing, photography, and art books. Janik is a graphic designer and an assistant art lecturer at Opole University.

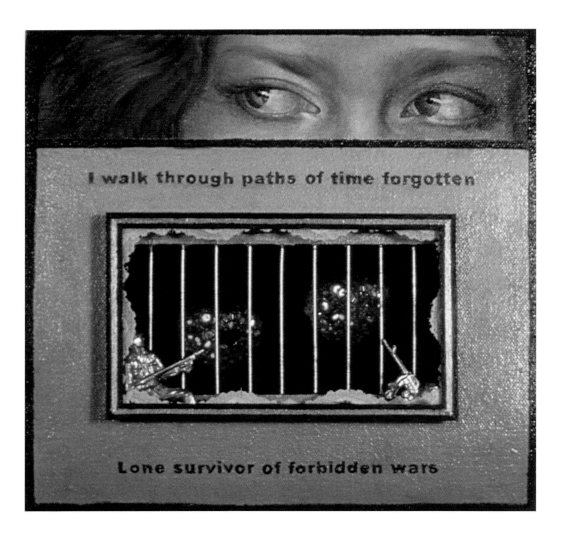

I walk through paths of time forgotten

Lone survivor of forbidden wars

MARGARIDA KENDALL

My theme is woman as the ultimate survivor. In my narrative paintings I record in metaphorical images personal reflections, social considerations, and random, unexplained occurrences. I also highlight the relationship between the illusion of reality and the physical world by combining flat painting surfaces with three-dimensional objects.

Margarida Kendall's work has appeared in galleries and museums in Washington, D.C., Baltimore, New York, Philadelphia, and Chicago. In Portugal she had a solo show at the Gulbenkian Center for Modern Art. She is an associate professor of studio art at George Mason University.

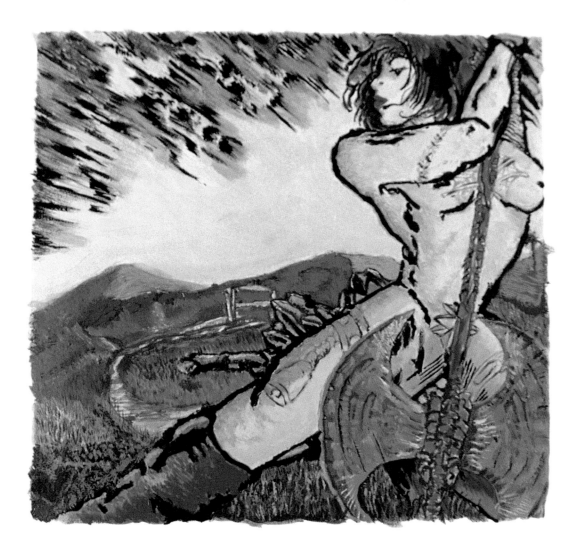

MARÍA DE MATER O'NEILL

Born in San Juan in 1960, María de Mater O'Neill holds a BFA from Cooper Union, in New York. She has worked as a graphic designer and as webmaster of the e-zine El cuarto del Quenepón. O'Neill has won a number of major awards, including the prestigious grand prize at the III Bienal Internacional de Pintura in Cuenca, Ecuador, and the Federal Design Achievement Award in her home country. The most recent of the numerous exhibitions in which she has taken part was "Litografía Argentina Contemporanea" at Buenos Aires's Museo Eduardo Sivori in 1999. In that same year, Rutgers University invited her to become artist-in-residence at the Center for Innovative Printmaking and Papermaking.

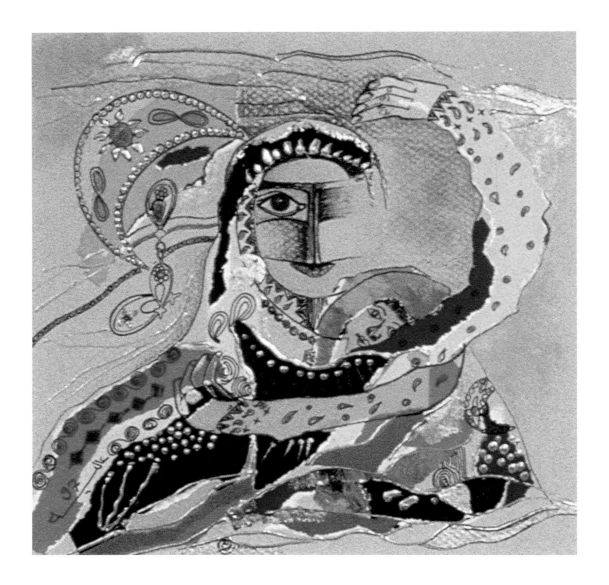

ALIA ABDUELA

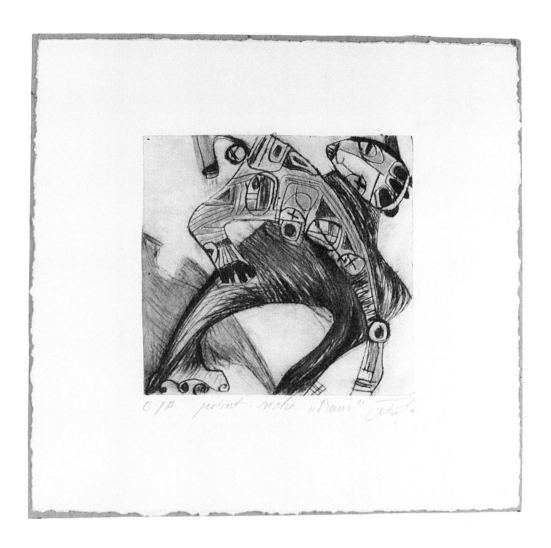

PETRUTA PANAIT (B. 1971)

The title of this piece is *Dance*: it is a sign of land, friendship, and love. In our hearts we have the power to be happy and the will to enjoy the stars and the beauty of this world.

Petruta Panait is interested in technical engraving. Her style affords a free and personal expression. Panait has participated in national and international exhibitions and contests. She produces advertising clips at a post-processing agency. Though this job takes most of her time, she still works in the Romanian tradition of engraving glass icons and small decorative objects.

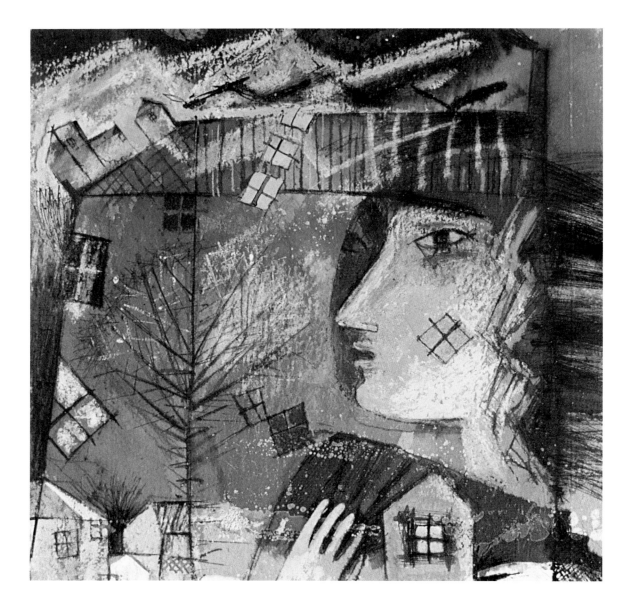

OLGA OKUNEVA (B. 1959)

Born in the Kuibyshev town of Otradnoye, Olga Okuneva moved in 1968 to Orenburg and studied art. She graduated from the Kharkov Art Industry School's Department of Drawing and Painting in 1987. Okuneva has been taking part in exhibitions since 1985.

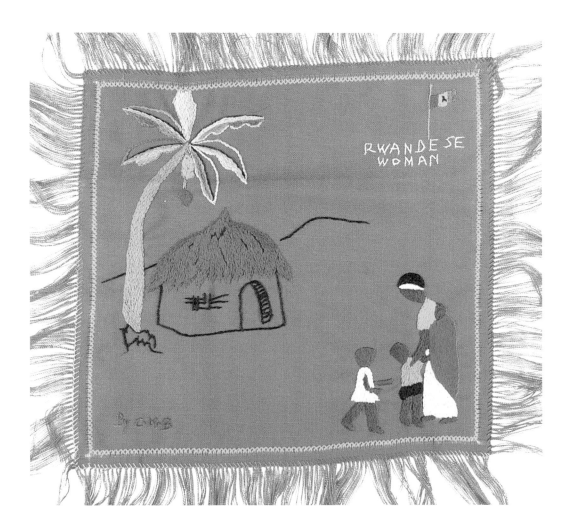

CLAUDIA BARASEBWA (B. 1963)

My piece contains a banana tree, a house for hospitality, a woman, and children of prosperity. The woman is the soul of my home. When she has visitors she offers a local drink made of banana or sorghum. She knows everything in the house and takes care of everyone.

Claudia Barasebwa combines a career in environmental matters with an interest in the arts.

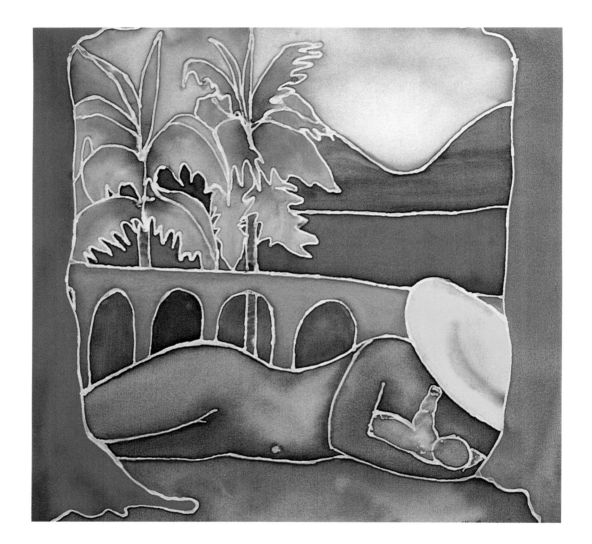

LILLY BERGASS (B. 1969)

Lilly Bergass learned how to paint on silk in 1991. Inspired by the vibrant colors and easy flow of the silk dyes, she began making wall pieces and scarves. Bergass paints by hand and steams the silk at home. She lives in Saint Lucia with her husband and two daughters.

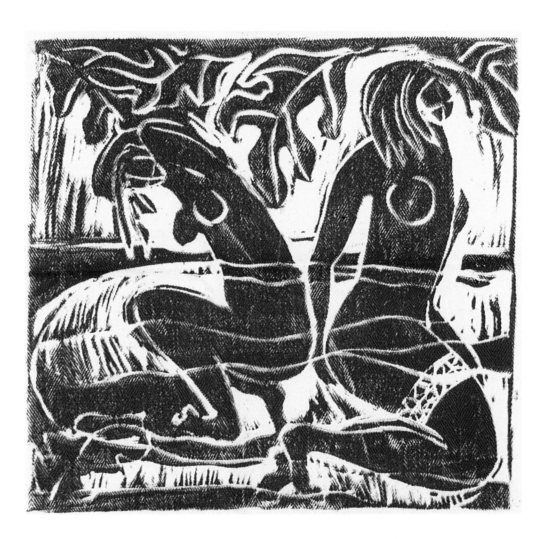

MOMOE MALIETOA VON REICHE (B. 1945)

This picture is about women bathing. In Samoa, bathing pertains to the saying "Cleanliness is next to godliness." No matter what trials and tribulations we suffer as woman, this final ablution of the day washes the slate clean. On another level, the picture depicts women's relationship to nature. A safe, healthy environment ensures a safe society.

Momoe Malietoa von Reiche is a painter and writer. Her MADD Art Gallery (Motivational Art Dance and Drama) features contemporary and traditional pieces. She has also published poetry and books for children.

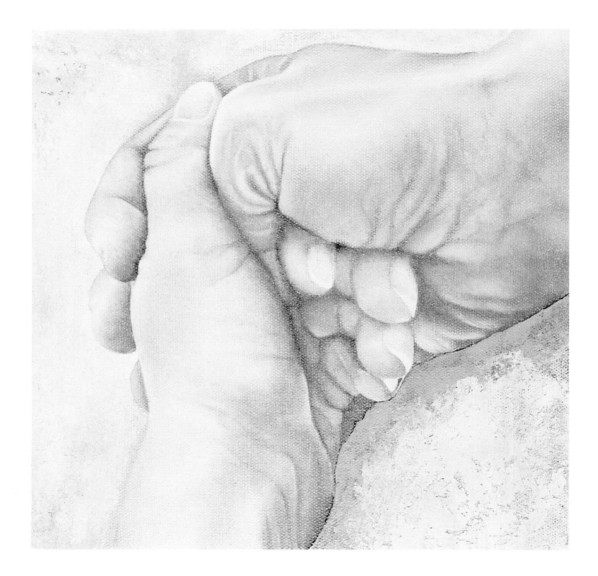

NICOLETTA CARATTONI (B. 1961)

Born in Italy, Nicoletta Carattoni is now a professor in San Marino. Since 1997, she has participated in group shows in San Marino, Italy, and Bulgaria.

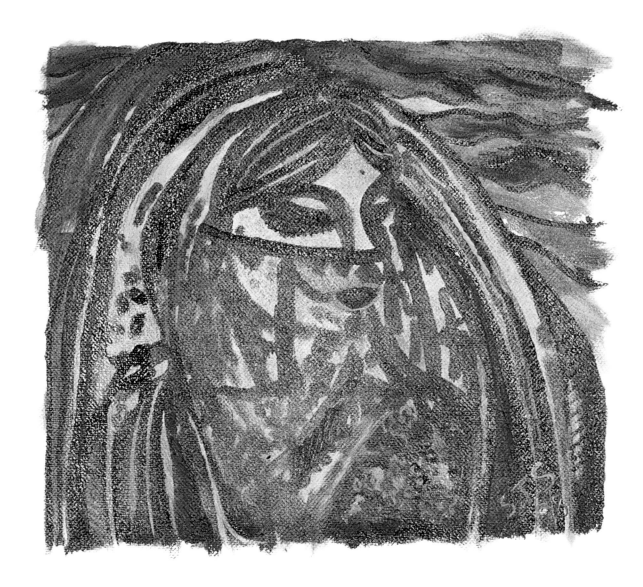

SHERRIFAH AL-SUDAIRY (B. 1958)

Sherrifah Al-Sudairy has exhibited in Saudi Arabia and abroad. She won first prize in the Women's Gulf Competition and third place in 1988, in Bahrain. She took fifth place in the International Biennial in Florence, Italy, in 1997. Al-Sudairy has an art gallery in Riyadh and hopes to encourage young artists in her country. She is married and has four children.

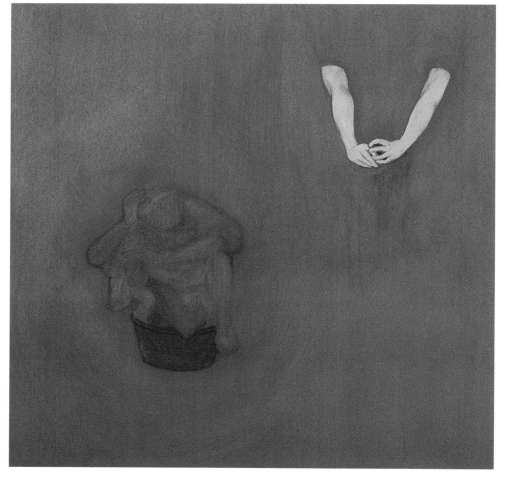

HELEN GRAHAM (B. 1965)

My work is inspired by emotions, many of them unmentioned or repressed. I am concerned with identity, and I make use of my personal history and gender issues to reflect the difficulties and pressures within society. Recognizable details and suggestive fragments of private worlds become reference points for the viewer. They convey contrasting and incompatible desires and fears: passion and aggression, seduction and rejection, absence and presence.

Helen Graham's art has appeared in group exhibitions in Scotland and abroad, including Shetland, Germany, and Spain. Graham has had solo shows in Scotland and Barcelona. She teaches art and design and is a social care worker for adults with learning difficulties.

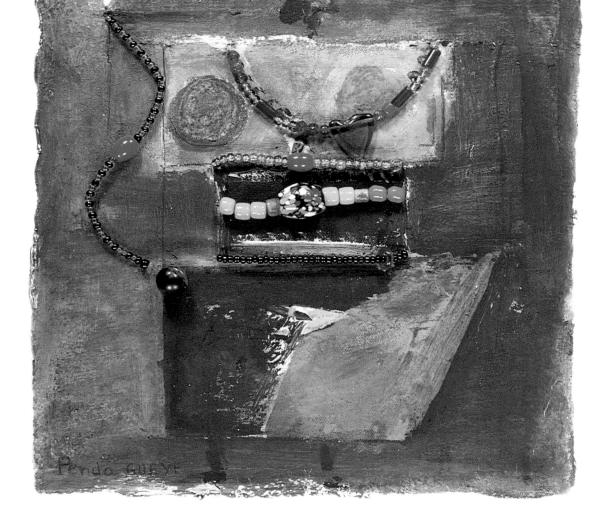

PENDA GUEYE

In my piece, the Senegalese woman considers the bead an object of seduction. The Senegalese woman expresses her fantasies by clothing her waist in colorful, rustling, and magical beads.

Art professor Penda Gueye has had annual exhibitions since 1982. She has been in group exhibitions in Senegal and around the world, including "Rise with the Sun: Women at Africa" in Canada and "Retrospective and Perspective of Senegalese Art from 1960 to Today," which received third prize from OCI, International Islamic Conference.

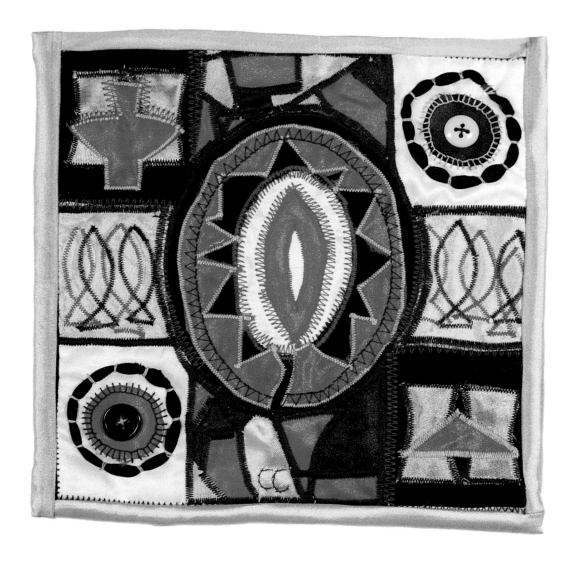

CHRISTINE CHETTY (B. 1969)

Through my work I question issues concerning the exploitation of women. I explore women's emotional, spiritual, and social conditions to make statements. I do not, however, polarize or separate women's issues from other global concerns. Ultimately, they affect us all.

Christine Chetty has participated in group shows at Seychelles' National Art Gallery. Her work has appeared in exhibitions in Portugal, India, and Malaysia, and is in private collections in India, the United States, the United Kingdom, and Malaysia. She teaches at the School of Visual Arts of the National College of the Arts in Seychelles.

KADIJAH ZAINAB FOFANAH

I look up to women who don't feel they have to make a choice between "femininity" and "masculinity." I love the women I grew up with. They farmed, ran businesses and home budgets, led communities, and were wives and mothers. My admiration led me to choose Guinean/Sierra Leonean Bah Hadja Binta Diallo as my subject. Bah is a businesswoman, wife, and mother of two daughters. She travels throughout the world; she and her husband live in Guinea while their daughters study in the United States.

Kadijah Zainab Fofanah, a Sierra Leonean and Guinean, is a government and politics major who has lived overseas since she was eleven. She wants to voice her opinions through photography, filmmaking, and journalism.

NONI KAUR (B. 1969)

A woman's sexuality, as spectator, must undergo transformation. As if she were a man with the phallic power of the gaze, she must look at a woman who would attract that gaze in order to be a woman. My body prints form a conscious and subconscious journey. I wish to explore and upset the oppressor–victim, active–passive dualities. I have to question every assumption and every reaction as a result of being culturally conditioned. The expression of my sensibilities and concerns does not stem from politicized feminism, but rather from a psychic bonding to my femaleness.

Noni Kaur, a Sikh, has exhibited in Australia, China, the United States, and in her country. She has worked with hearing-impaired children and is a lecturer in the Department of 2-D Studies, LaSalle-SIA College of Arts, Singapore.

DENISE LEHOCKA (B. 1971)

Since 1994, Denise Lehocka has had solo shows in Bratislava, Prague, and Kosice. Her work has appeared in group exhibitions in Vienna, Budapest, Belgium, Russia, the Czech Republic, and at the Venice Biennial at the Slovak Pavilion.

Jasna Hribernik – Ballabende
1995

JASNA HRIBERNIK

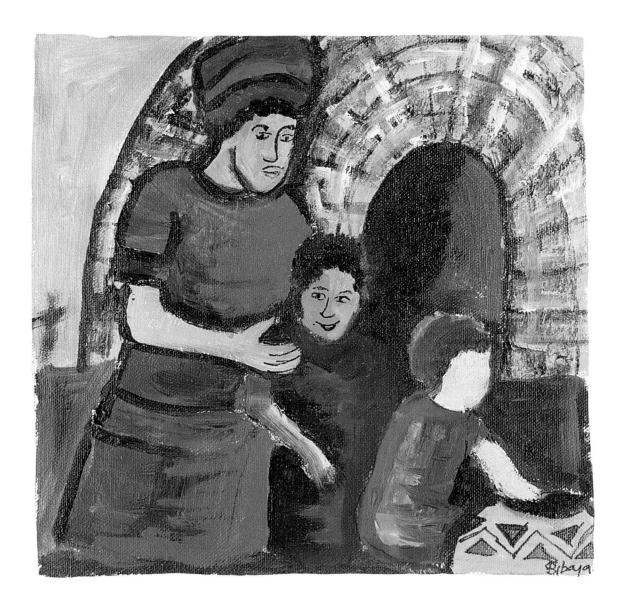

PHILISIWE SIBAYA (B. 1973)

My work is influenced by my social landscape, and I'm inspired by cultural diversity.

Philisiwe Sibaya's interest in art and culture has led to her to become active in art education. Her paintings and prints have appeared in national and international galleries and are in private and corporate collections in Namibia, Algeria, Germany, the United States, and the Netherlands, among others.

MABI REVUELTA (B. 1967)

Anatomy of Love: the body wears skin, our superficial suit and protecting robe. Skin is also our present to love. Knowing this garment by the tactile sense is the best way to animate the erotic pulse and to explore the imaginative human being.

Mabi Revuelta, a resident of Bilbao, has had solo exhibitions in Pamplona, Bilbao, and Bizkaia. She has won grants and fellowships. Since 1995, her work has been in group shows at the Old Museum of Contemporary Arts of Madrid and the Guggenheim Museum in Bilbao, among others.

SURANI FERNANDO (B. 1945)

Women have important roles as wives, mothers, and daughters. If a woman can help raise a principled and dutiful child, she can make this world a better place.

Surani Fernando is a promotional designer and makes paintings and handicrafts.

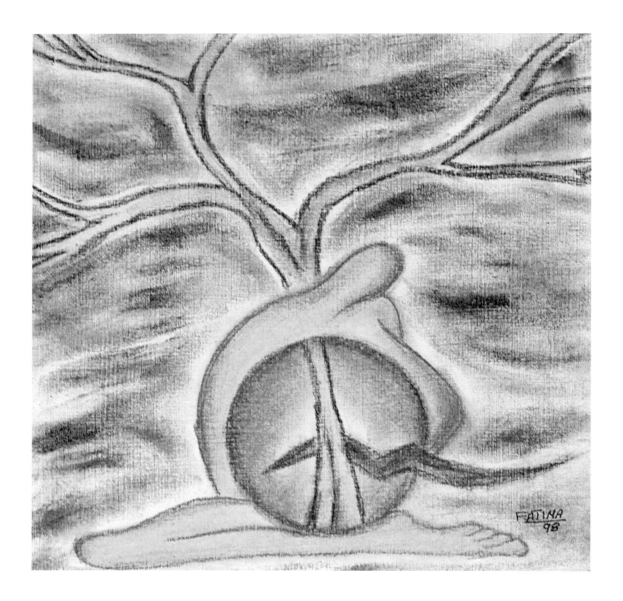

FATIMA ABDL RAHIM ELHAT

The woman is the soul of life in Sudan, yet she is weakened by ethnic traditions. This painting shows Eve engulfing life, despite her lack of power.

YVONNE PONT

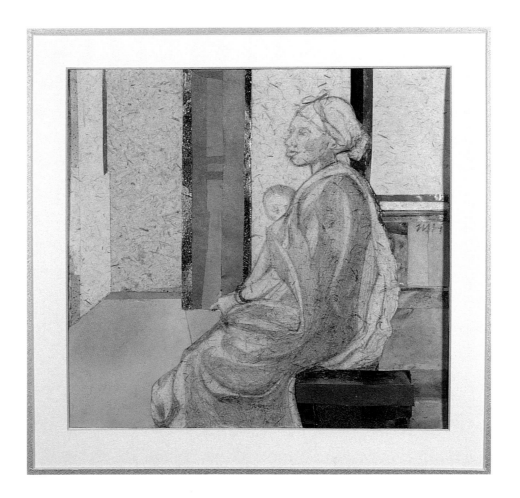

MARGOT HORN (B. 1936)

I find themes for drawing, oils, and collages in the light and forms of Cape vernacular architecture and in the granite landscape of Swaziland. Swazi culture is summed up in its women, especially their patience through daily hardship. Male polygamy often means women have the sole care of children, even though they also work in the fields or as street vendors. I see them waiting at crowded bus stops, banks, government offices, hospitals, and clinics. I wanted the figure at the clinic to convey dignity, space, and simplicity.

Margot Horn has given art history lectures in Mbabane and has had a solo exhibition at the Indingilizi Gallery. She works mainly in oils and collage. Churches and other groups have commissioned her for carvings, collages, and paintings.

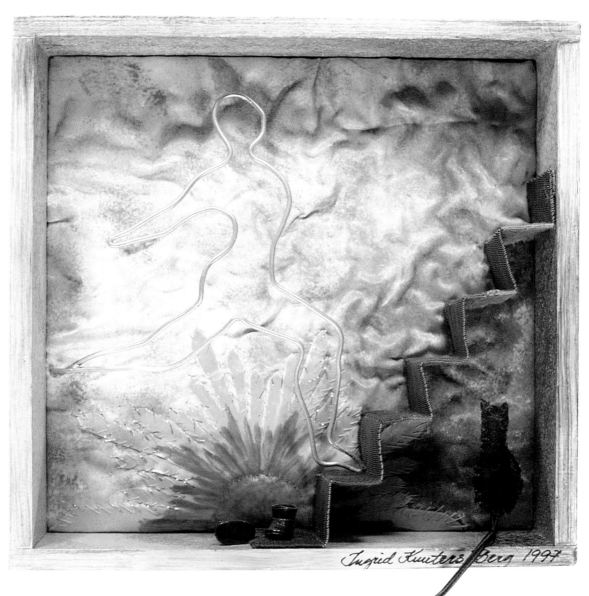

INGRID KNUTERS-BERG

The woman is like the sun, providing warmth and strength. The shoes symbolize that a woman likes challenges; the cat shows a woman's individuality. Yellow and blue signify Sweden.

EVA OLGIATI

People say there is a difference between the female and the male artist. Sometimes I admit I have to agree. But most of the time, I refuse to accept it.

Eva Olgiati was born in Chur in 1961. She studied art and design in Switzerland and in the U.S., and has worked as a fashion designer, as an art teacher, and—since 1994—as a fulltime artist.

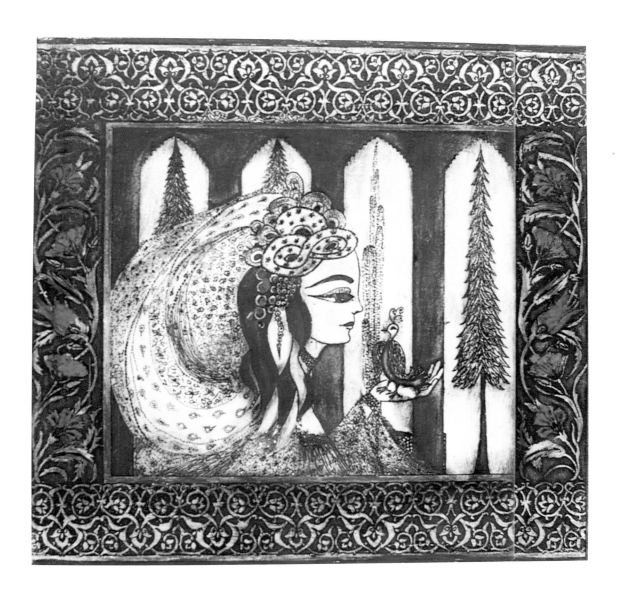

KHAIRAT AL-SALEH

Of all the Arabian Nights stories, the storyteller's is the most beautiful and imaginative: a young, defenseless girl sets out to save other women. The king's wife, Scheherazade, represents the woman as an artist: creative, a weaver of dreams, compassionate, and intuitive.

Ceramist Khairat Al-Saleh has written poetry and a book on Arab mythology.

HSIN-HSI CHEN (B. 1969)

My work is based on Eastern and Western art filtered through a personal vision. I am devoted to finding the truth of the human spirit. My work presents the synchronicity of events that surrounds the relationship between humans and nature in a black-and-white world.

Hsin-Hsi Chen is a graphic designer whose work has been reviewed in major journals and newspapers in the United States. She is on the cover of the Winter 1999 issue of Signs: Journal of Women in Culture and Society. *Her work has been in solo and group exhibitions in the United States and Taiwan, and it is in collections in Taiwan, the United States, and Ireland.*

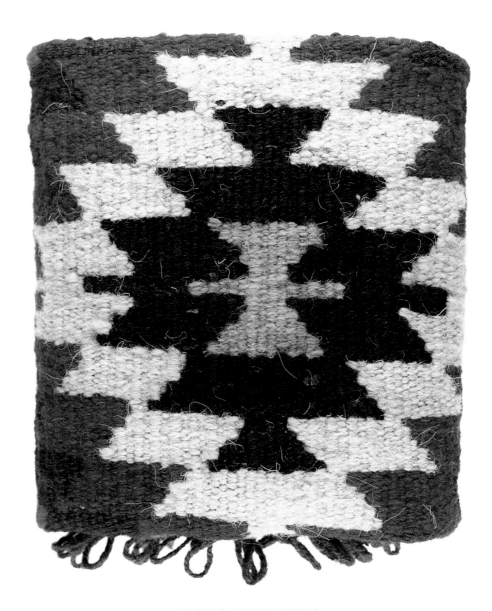

RAYA TURAEVA

My carpets are handmade from pure sheep's wool. I use traditional Tajik ornaments and natural colors.

Raya Turaeva learned the secrets of carpet-weaving from her mother-in-law, whose family is famous for their weaving skills. She wants to pass on her knowledge and experience to her daughters.

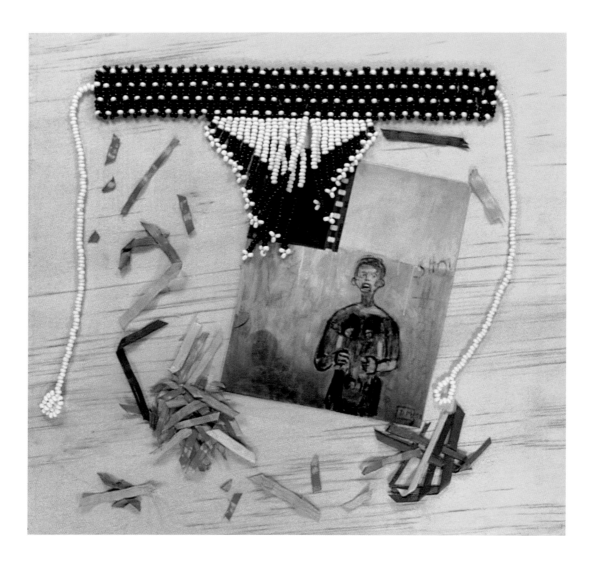

DOREEN MANDAWA (B. 1929)

I have juggled the roles of daughter, student, nurse, wife, mother, and artist. Each was creatively fulfilling. Age takes its toll; nevertheless, I keep painting to express myself. Some of my paintings reflect my politics; others, womanhood.

Born in Edinburgh, Doreen Mandawa married a South African of Asian descent, moved to Tanzania in 1964, and had two daughters. Now a Tanzanian citizen, she is inspired by her adopted country and occasionally uses local mythology in her work.

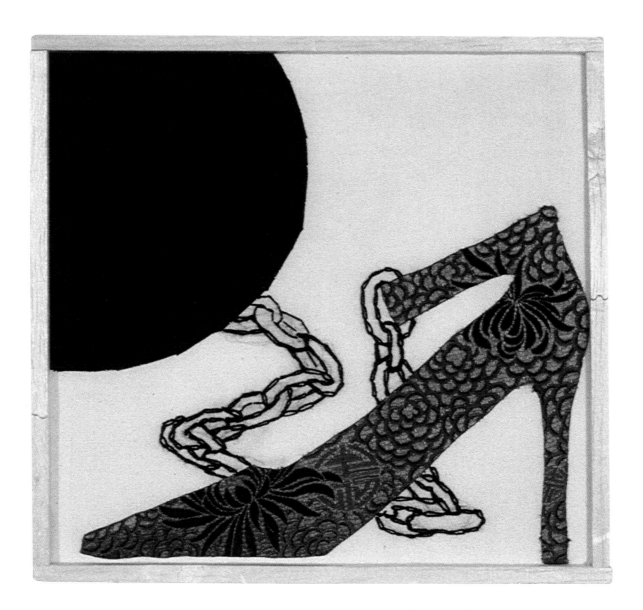

WORAPANIT JIYA-AMONDEJ (B. 1974)

My concept is female restriction in Thailand.

Worapanit Jiya-amondej received a degree in art from Chulalongkorn University.

AMIVI HOMAWOO (B. 1975)

In my culture, the woman is the symbol and source of life. She is the center of the family and society. She is strength and love.

Amivi Homawoo has studied stage design, painting, sculpture, and printmaking in Togo and France. Since 1995, her work has been shown in Togo, Benin, and Burkina Faso. She is a decorator and a designer of games and toys.

KATHERINE WILLIAMS (B. 1941)

Pelau (pronounced PAY-low) is a dish from Trinidad and Tobago accented with African, Indian, Chinese, and European flavors.

Dr. Williams has had solo shows in Virginia, Massachusetts, and Washington, D.C. After traveling around the world, Williams wrote her first collection of poetry, Journeying*. She is listed in "Who's Who" books.*

LATIFA OTHMANI

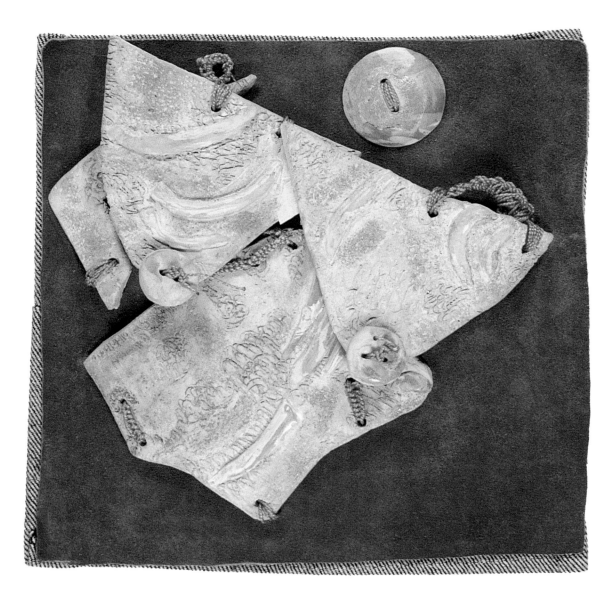

FERHAN TAYLAN ERDER

YAZNUR OVGANOVA (B. 1977)

Most of my paintings are devoted to Turkmen women. Despite the traditional Muslim view, the Turkmen woman plays an important role in families and society. She raises children and often resolves vital family issues. Even the well-known hero of the Turkmen-Persian wars, Gowshut-Khan, used to say, "I'm king of everyone, but at home I'm a slave."

Yaznur Ovganova attends the Institute of World Languages in Ashgabat. She has participated in national exhibitions. In 1996 she won a prize in a United Nations competition; in 1998 she was in a Ovganov family art exhibition with her father, a well-known Turkmen artist.

LILIAN NABULIME (B. 1963)

Maama: in the Badanda culture a woman is expected to be a mother to all. Even young girls are called *maama*, or "future mothers." As they grow older they become role models who are expected to be tender, loving, and caring.

Lilian Nabulime is a lecturer at the Sculpture Department of Makerere University. She has participated in solo and group exhibitions in South Africa, the United States, the Netherlands, Belgium, Scotland, and Germany, among others. In 1997 she received a fellowship to the Glasgow School of Art.

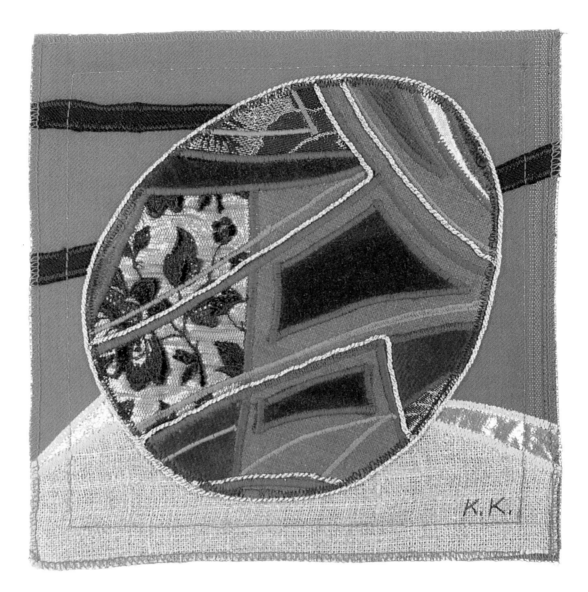

KATERINA KORNIYCHUK (B. 1960)

————

I use different printing techniques, but I prefer original graphics, where I can combine printing and handmade work.

Katerina Korniychuk has been in exhibitions in the Ukraine, the United States, Canada, Russia, England, and France. Korniychuk has received various honors, including a Soros Foundation grant. Her work is in public and private collections in the Ukraine, Russia, and the United States. She is the art director of an ad agency and has worked in stage and costume design.

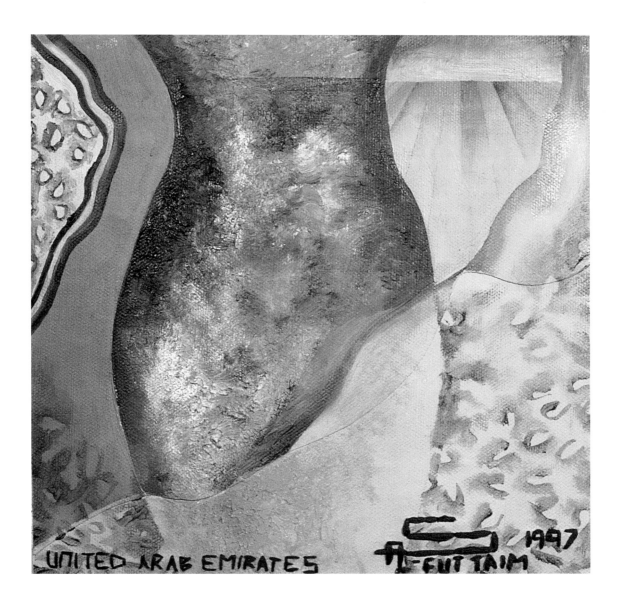

SARAH M. AL-FUTTAIM

It is difficult for me to describe the sensory appearance of my paintings, especially when they evolve from subconscious levels. This labyrinth contains all experience with varied patterns and forms until those that are most significant spurt onto the canvas. In the words of Francis Bacon: "The job of the artist is always to deepen the mystery."

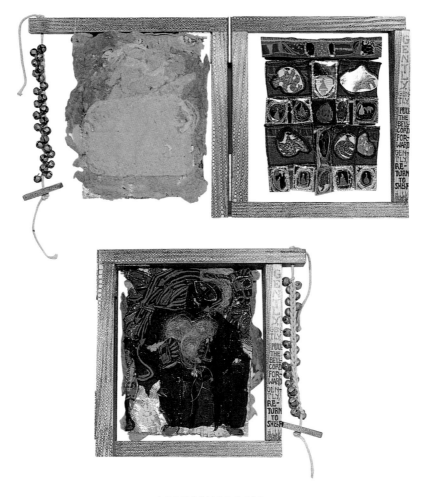

ANONYMOUS

Woman's power and passion, I do believe, lie in conceiving and nourishing the children of
the flesh or mind, heart borne.
She dances firm upon the earth, begetting stars and bells of David.
She eats the apple, true. But—too—her foot can hold the serpent down.
When is butterfly born? Where's the fly's address?

Humaning bird whirra from flower to flower jetting for food if food there be.
Salmon fights rapids to reach home base; if not to reach, how spawn at all.
Oak tree roots deep into Mother Earth promising birdnests and nuts to come.
Ma bird shows chicks to bathe off nits, so may chicks live to show their own.
Snow leopard trails silence alone and unseen, learning what it is to be.
As with them, just so with me.

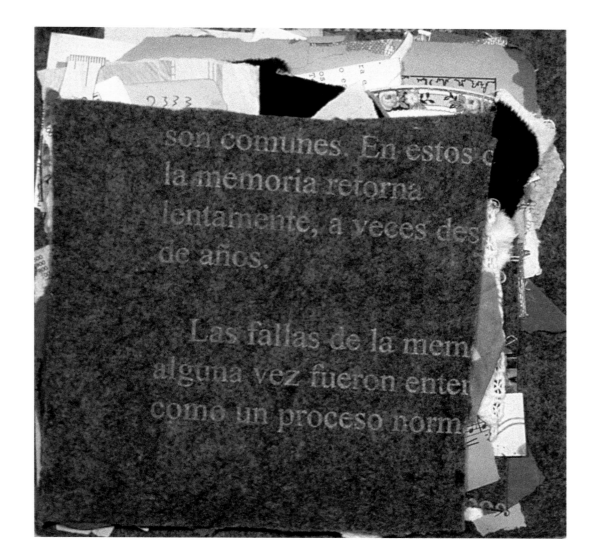

ANA TISCORNIA (B. 1951)

My artwork describes the forgotten events and experiences throughout history and the political and philosophical consequences. Depending on the inspiration, I might create an installation, an architectural invention, or small, two- or three-dimensional objects that form one piece.

Born in Uruguay, Ana Tiscornia became a United States resident in 1991 and teaches at universities. She is a curator and writes for Brecha *(Uruguay),* Atlantica International *(Spain), and* Art Nexus *(Colombia).*

MAKHBUBA ERGASHEVA

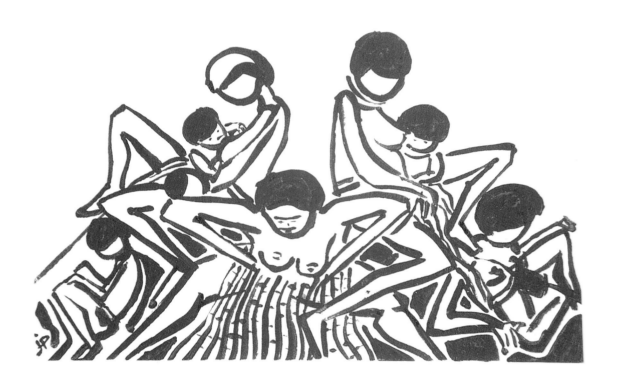

JULIETTE PITA

My piece symbolizes women voicing their concerns about those women and children who are treated badly by men.

Juliette Pita studied tapestry and has been in group exhibitions since 1983. In 1996 she participated in the New Caledonia Biennial of Contemporary Art. Pita was a founding member of the Nawita Association, an association for local artists in Vanuatu. Pita is a mother and paints fabric part-time.

AURORA RINCON

I love exploring the figure by creating disproportionate appearances with deep expressions, textured marks, and movement. Stemming from my expressions, attitudes, feelings, dreams, perspectives, and frustrations, the figures then develop a unique history.

Aurora Rincon was born in Venezuela and is now a United States citizen. Her work has appeared in the Cultural Center of the Embassy of Venezuela, the Corcoran Gallery of Art, World Bank, and other galleries in the Washington, D.C., area.

DARLENE NGUYEN-ELY (B. 1968)

Woman:

1: a fully grown human female 2: women in general: woman lives longer than man in most countries. 3: a woman in employment in a house or who serves a queen: the queen's women surrounded her. 4: (a female person with) female nature or qualities, such as caring for weak creatures, personal attractiveness, and interest in people; a man with something of the woman in him. 5: female: women workers. 6: a wife, lover, or woman with whom a man lives: the woman in his life. 7: woman of the world: an experienced woman who knows how people behave.

Darlene Nguyen-Ely's work has appeared in solo and group exhibitions in the United States and Canada. She has received awards and grants from the Elizabeth Greenshield Foundation, the Pollock-Krasner Foundation, and other institutions.

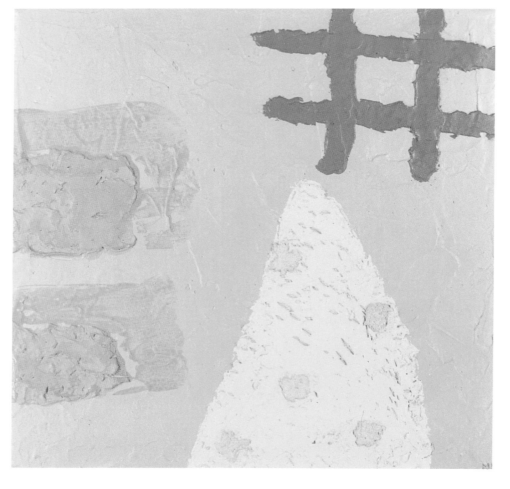

MAGGIE HENSHALL (B. 1964)

Coming from a small Welsh valley community, where nearly all baby girls are dressed in pink and boys in blue, I felt that *pink for a girl* would be an apt, if tongue-in-cheek, title for my painting. The piece of oak onto which the work is painted is a panel from a discarded piece of Welsh furniture. The initial sketches I made of land and water in Cardiff Bay gave me a starting point for the painting.

Maggie Henshall was born in South Wales and now lives in Penzance with her husband and daughter. Exhibiting throughout Britain, she is represented by private galleries and supplies art to commercial enterprises in London. In 1998 she received her first public commission.

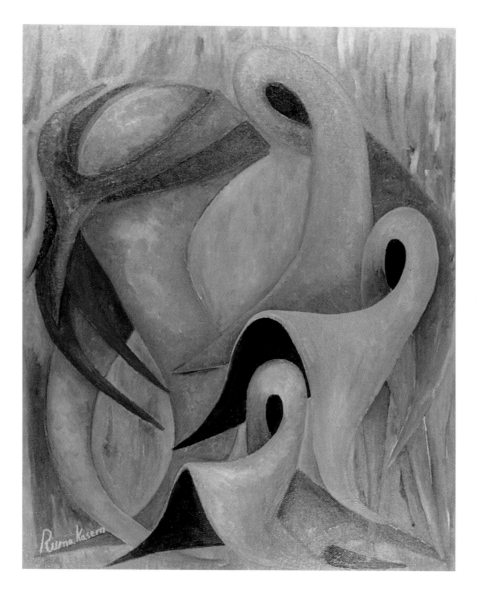

REIMA QASEM (B. 1969)

Educator Reima Qasem has organized exhibitions for children in Yemen. Qasem exhibits nationally and internationally. Among her honors is the second prize in the National Competition of Fine Arts in Sana'a in 1996. She had her first solo exhibition in San'a in 1996.

NINA KOCIC (B. 1961)

————————

Sculptor Nina Kocic had her first solo show in Belgrade in 1992. Kocic won an award for an experimental video at the Belgrade Short Films Festival in 1992. She received a grand prize for sculpture at the Biennial of Young Artists in Vrsac.

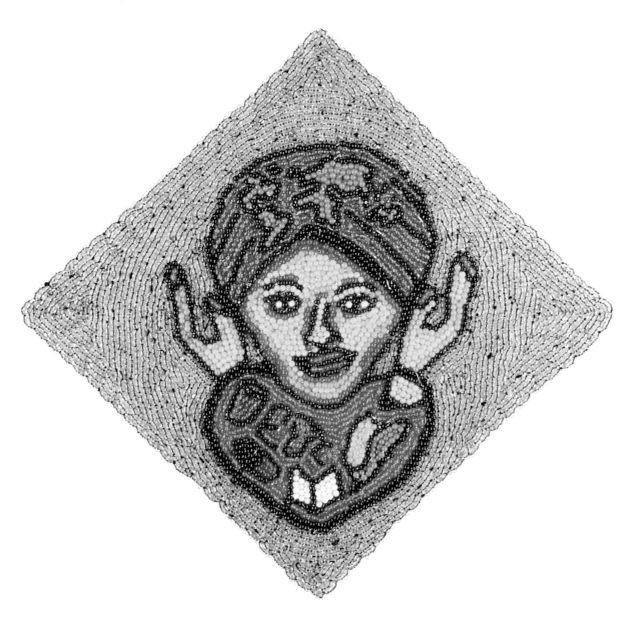

NAMAKAU-NALUMANGO (B. 1957)

The women in beads are like an African woman carrying the world with all its problems on her head. A woman can do it all because she has a big heart.

Namakau-Nalumango has taught elementary school and was a resource teacher to the blind. She is a school counselor and makes collages and beadworks.

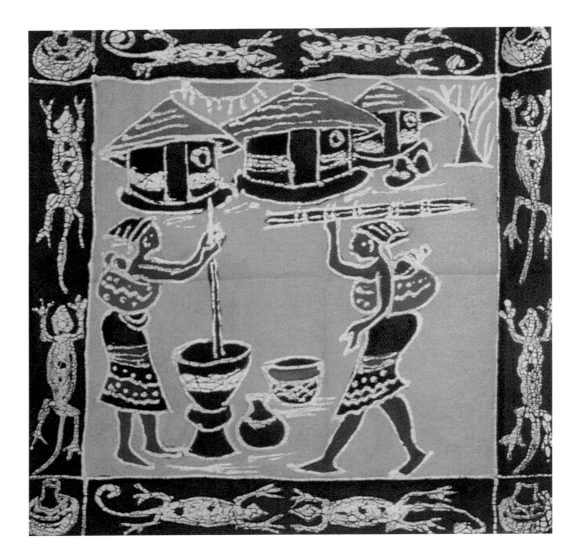

ABGAIL KZINGIRE (B. 1968)

Abgail Kzingire has taught batik in Sweden and Mozambique. She has participated in exhibitions and has won an award in textiles.

Abad, Pacita (Philippines) 140
Abani, Mariam (Libya) 102
Abduela, Alia (Qatar) 144
Agueznay, Malika (Morocco) 120
Al Lawatia, Nadira Mahmoud (Oman) 132
Al-Attar, Suad (Iraq) 85
Al-Baqsami, Thuraya (Kuwait) 95
Al-Futtaim, Sarah M. (United Arab Emirates) 179
Al-Saleh, Khaira (Syria) 167
Al-Sudairy, Sherrifah (Saudi Arabia) 151
Amoussou-Guenon, Sylvie Brigitte (Benin) 34
Bailey, Barbara (New Zealand) 126
Barasebwa, Claudia (Rwanda) 147
Bergass, Lilly (Saint Lucia) 148
Berriolo, Elena (Italy) 88
Brandao de Alfu, Dalys (Panama) 136
Callebaut, Nicole (Belgium) 32
Carattoni, Nicoletta (San Marino) 150
Carletidou, Marlen (Cyprus) 54
Carrol, Ruth Ajolla (Gambia) 69
Caruana, Josette (Malta) 112
Chen, Hsin-Hsi (Taiwan) 168
Chetty, Christine (Seychelles) 154
Chibambo, Febbie (Malawi) 108
Cugat-Galano, Charlette (France) 68
Dabre, Catherine (Burkina Faso) 41
De Sigaldi, Emma (Monaco) 118
Derrick, Pat (England) 63
Do Rosario da Silveira Braganca, Silvia (Mozambique) 121
Doram, Heather (Antigua) 21
Dujmovic, Marija (Herzegovina) 37
Duncan, Maylene (Guyana) 76
Duque, Adriana (Colombia) 49
Edwards, Linda (Canada) 45
El Razzaz, Dina (Egypt) 61
Elhat, Fatima Abdl Rahim (Sudan) 162
Emmanuel, Josefina Manzaila (Angola) 20
Epie, Irene (Cameroon) 44
Erder, Ferhan Taylan (Turkey) 175
Ergasheva, Makhbuba (Uzbekistan) 182
Eski, Marjana (Albania) 18
Fakhro, Fatima (Bahrain) 28
Fernando, Surani (Sri Lanka) 161
Fofanah, Kadijah Zainab (Sierra Leone) 155
Gahssib, Riham (Jordan) 91
Gardner, Joscelyn (Barbados) 30
Garshtea, Elena (Moldova) 117
Geiger, Anna Bella (Brazil) 39
Ghatol (Afghanistan) 17
Giri, Pramili (Nepal) 124
Gorostiaga, Irma (Paraguay) 138
Graham, Helen (Scotland) 152
Gueye, Penda (Senegal) 153
Gupta, Jhumka (India) 82
Gyulamirian, Nene (Armenia) 23
Halpin, Andrea (Ireland) 86
Hansen, Anneliese (Denmark) 57
Hazelle, Maureen (Ghana) 72

Henshall, Maggie (Wales) 186
Heusner-Superville, Rachael (Belize) 33
Hilmi, Nabila (Palestine) 135
Hlavata, Hata (Czech Republic) 55
Homawoo, Amivi (Togo) 172
Horn, Margot (Swaziland) 164
Hribernik, Jasna (Slovenia) 158
Hull, Teresa Camacho (Bolivia) 36
Hutchinson, Carla Armour (Dominica) 58
Ifeta, Chris Funke (Nigeria) 129
Iguelmamene, Fatiha (Algeria) 19
Jahan, Ishrat (Bangladesh) 29
Jalkhaajavyn Munkhtsetseg (Mongolia) 119
Janik, Aleksandra Anna (Poland) 141
Jimenez, Amelia (Chile) 47
Jiya-amondej, Worapanit (Thailand) 171
Jonikiene, Lina (Lithuania) 104
Kaman, Gyongyi (Hungary) 80
Kamelo, Caritas (Burundi) 42
Karlisima (El Salvador) 62
Kaufman-Buchel, Elisabeth (Liechtenstein) 103
Kaziende, Marie (Niger) 128
Kendall, Margarida (Portugal) 142
Khan, Naiza H. (Pakistan) 133
Khun, Myriam (Guatemala) 75
Kim, Sumita (South Korea) 94
King, Cecelia (Liberia) 101
Klingler, Reingard (Austria) 25
Knuters-Berg, Ingrid (Sweden) 165
Kocic, Nina (Yugoslavia) 188
Korniychuk, Katerina (Ukraine) 178
Krupenkova, Olga (Belarus) 31
Kuiper, Klara (Netherlands) 125
Kupzashivili, Sofia (Georgia) 70
Kzingire, Abgail (Zimbabwe) 190
Lam, Jun-Ann (Malaysia) 109
Lampila, Tuire (Finland) 67
Lehocka, Denise (Slovak Republic) 157
Leon, Jolok (Marshall Islands) 113
Luckeenarain, Neermala (Mauritius) 115
Mac Callum, Barbara (Northern Ireland) 130
Mamadova, Arifa (Azerbaijan) 26
Mandawa, Doreen (Tanzania) 170
Mandrile, Cecilia (Argentina) 22
Mannor, Margalit (Israel) 87
Matheus, Thabea (Namibia) 123
Matome, Neo (Botswana) 38
Matuschek, Christine (Grenada) 74
Maycock, Jessica (Bahamas) 27
Meiramoglou, Despina (Greece) 73
Mejia, Xenia (Honduras) 78
Mim, Theoung (Cambodia) 43
Mokarem, Amal (Lebanon) 99
Monnin, Pascale (Haiti) 77
Morrison, Petrona (Jamaica) 89
Moteska, Monika (Macedonia) 106
Moundzota, Annie (Congo-Brazzavil) 50
Musavai, Gulnara (Kyrgyzstan) 96
Nabulime, Lilian (Uganda) 177

Namakau-Nalumango (Zambia) 189
Ndolo, Nathalie (Democratic Republic of Congo) 56
Nguyen-Ely, Darlene (Vietnam) 185
Noni Kaur (Singapore) 156
O'Neill, Maria de Mater (Puerto Rico) 143
Okuneva, Olga (Russia) 146
Olgiati, Eva (Switzerland) 166
Othmani, Latifa (Tunisia) 174
Ovganova, Yaznur (Turkmenistan) 176
Palau, Marta (Mexico) 116
Panait, Petruta (Romania) 145
Pere, Katrin (Estonia) 65
Perez, Iris Viviana (Dominican Republic) 59
Perez, Yasbel (Cuba) 53
Pita, Juliette (Vanuatu) 183
Pollak, Jenny (Australia) 24
Ponce de Leon, Milagros (Peru) 139
Pont, Yvonne (Suriname) 163
Pooya, Negar (Iran) 84
Popnedeleva, Adelina (Bulgaria) 40
Putrama, Zaiga (Latvia) 98
Qasem, Reima (Yemen) 187
Rasjid, Astari (Indonesia) 83
Razanamaro, Mamialisoa (Madagascar) 107
Revuelta, Mabi (Spain) 160
Rincon, Aurora (Venezuela) 184
Rodesch, Yvonne (Luxembourg) 105
Saemundsdottir, Soffia (Iceland) 81
Sequeira dos Santos Duarte, Isabel Lima (Cape Verde) 46
Shiraani, Fathmath (Maldives) 110
Sibaya, Philisiwe (South Africa) 159
Singh, Sangeeta (Fiji) 66
Struve, Rommy E. (Ecuador) 60
Telite, Maseabata (Lesotho) 100
Temnewo, Elsa Yacob (Eritrea) 64
Terstappen, Claudia (Germany) 71
Thiam, Nene (Mali) 111
Thinn, Zeyar (Myanmar) 122
Timsina, Dewaki (Bhutan) 35
Tiscornia, Ana (Uruguay) 181
Turaeva, Raya (Tajikistan) 169
Tyler, Virginia (Ghana) 72
Vidales, Marite (Costa Rica) 51
Von Reiche, Momoe Malietoa (Samoa) 149
Vorobjeva, Yelena (Kazakhstan) 92
Vuk, Sonja (Croatia) 52
Waelgaard, Line (Norway) 131
Wanjiku, Naomi (Kenya) 93
Weoa, Winnie (Papua New Guinea) 137
Williams, Katherine (Trinidad and Tobago) 173
Wong Chi Hang (Hong Kong) 79
Yano, Noriko (Japan) 90
Yu Shi Xu (China) 48
Zamora, Maria José (Nicaragua) 127